the
concise illustrator's
reference manual
figures

CHARTWELL
BOOKS, INC.

A QUARTO BOOK

Copyright © Quarto Publishing Inc.

Published by Chartwell Books Inc.
A division of Book Sales Inc.
P.O. Box 7100, Edison,
New Jersey 08818-7100

ISBN 0-7858-0515-X

This edition printed 1995

This book was designed and produced by
Quarto Publishing Inc.
The Old Brewery, 6 Blundell Street
London N7 9BH

Designer: Neal Cobourne
Photographers: Mick Dunn & Dick Hatfield
Assistant Editor: Peg Osterman

Printed in Hong Kong by Regent Publishing Services

CONTENTS

SPORT AND LEISURE

1.01 Skiing - schuss
1.02 Skier - carrying skis
1.03 Skiing - admiring the view
1.04 Golf - admiring the shot
1.05 Golf - addressing the ball
1.06 Golf - backswing
1.07 Tennis - ready to receive
1.08 Tennis - forehand drive
1.09 Badminton - smash
1.10 Squash - forehand
1.11 Squash - backhand
1.12 Cricket - defensive block
1.13 Cricket - waiting to bat
1.14 Throwing a ball
1.15 Tossing up a ball
1.16 Billiards
1.17 Bowling
1.18 Soccer - throw-in
1.19 Running - sprinter on the block
1.20 Rugby - passing
1.21 Rugby - drop kick
1.22 Basketball - dribbling
1.23 Basketball - shooting
1.24 Boxing - classic guard
1.25 Boxing - jabbing
1.26 Boxing - the winner
1.27 Weightlifting - one-arm dumbbell
1.28 Weightlifting - bar under chin
1.29 Skipping rope
1.30 Gymnastics
1.31 Gymnastics - headstand
1.32 Exercising
1.33 Exercising - toe touch
1.34 Exercising - end of the workout
1.35 Exercising - stretching
1.36 Yoga
1.37 Yoga
1.38 Yoga
1.39 Skateboarding
1.40 Walking the dog
1.41 Walking with stick
1.42 Playing cards
1.43 Artist painting

SITTING

2.01 Backwards on a chair
2.02 In a chair doing the crossword
2.03 In a chair looking through an
 address book
2.04 Sideways in a chair
2.05 Kneeling on a chair and talking
 on the phone
2.06 On a bar stool
2.07 Priest asleep in a rocking chair
2.08 On the floor thinking
2.09 On the floor

PERSON TO PERSON

3.01 Couple kissing
3.02 Waving goodbye
3.03 Crying into handkerchief
3.04 Kissing goodbye
3.05 GI greeting his girl
3.06 Greeting a friend
3.07 Couple sitting
3.08 Couple sitting at a table
3.09 Bully threatening someone
3.10 Cowering on the ground
3.11 Taking the lady home
3.12 Couple at the beach
3.13 Praying

LAW AND ORDER

4.01 New York policeman - stop!
4.02 New York policeman directing traffic
4.03 Saluting
4.04 Gangster with violin case

THE WORKING DAY

5.01 Hailing a taxi
5.02 Running and looking at watch
5.03 Opening an umbrella
5.04 Standing under an umbrella
5.05 Taking dictation
5.06 Commuting
5.07 Heavy suitcase
5.08 On the phone
5.09 Typing

CARRYING

6.01 Stack of boxes
6.02 Large plant
6.03 Step ladder
6.04 Smelly socks

DOMESTIC

7.01 Painting with a roller
7.02 Leaning on a broom
7.03 Sawing
7.04 Hammering
7.05 Painting with a brush

EATING AND DRINKING

8.01 Eating sandwiches and drinking tea
8.02 Drinking from a teacup and saucer
8.03 Priest with tea and biscuits
8.04 Waitress with tray

MUSIC AND ENTERTAINMENT

9.01 Rock and roll dancing
9.02 Ballroom dancing - quickstep
9.03 Ballroom dancing - waltz
9.04 Ballroom dancing - tango
9.05 Disco dancing
9.06 Conducting - vivace
9.07 Conducting - adagio
9.08 Playing the clarinet
9.09 Playing the double bass
9.10 Playing the violin
9.11 Opera singer
9.12 Rock singer
9.13 Playing the acoustic guitar
9.14 Playing the electric guitar
9.15 Playing the keyboard
9.16 Jazz trumpeter

DRESSING

10.01 Putting on a hat
10.02 Putting on a jacket
10.03 Putting on trousers
10.04 Putting on socks
10.05 Putting on shoes
10.06 Taking off boots
10.07 Drying hair

PIN-UPS

11.01 Pin-up
11.02 Pin-up
11.03 Pin-up
11.04 Pin-up
11.05 Pin-up
11.06 Pin-up
11.07 Pin-up
11.08 Pin-up

USING THE FIGURE REFERENCE MANUAL

This manual comprises 122 "poses" categorized under 11 general headings. Each category has an index code, and within each category each pose has a further sub-index code for ease of reference.

Each pose is presented from six angles. The images are as large as the pose will conveniently allow. A consistent scale is maintained within the camera angles on each pose, but the scale may change from one pose to another.

Waist-level camera angle

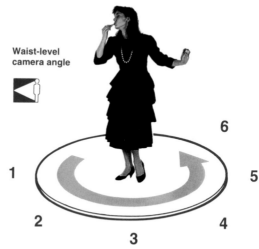

Each pose is presented from six angles, achieved by using a waist-level camera and a turntable rotated through 360 degrees

Category heading

Pose title

AND ENTERTAINMENT

keyboard

9·15

Index and sub-index code

Composite figures can be drawn using elements from different poses.

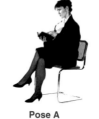

Pose A

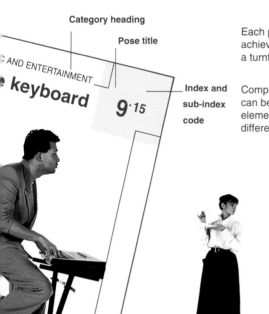

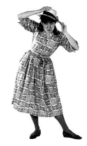

Pose B

Pose C

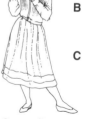

A

B

C

Composite pose

1·01 Skiing - schuss

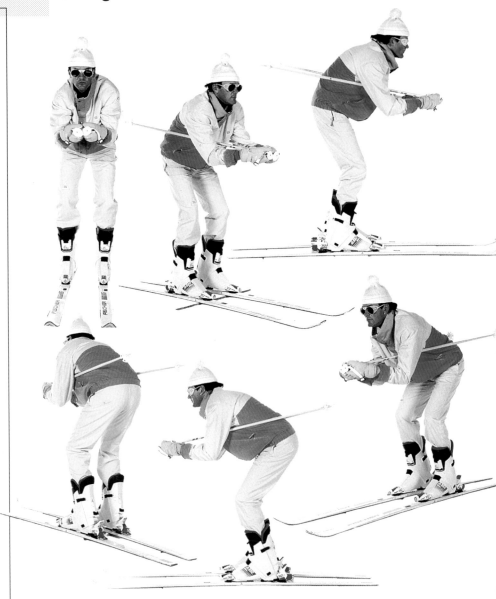

Skier - carrying skis 1·02

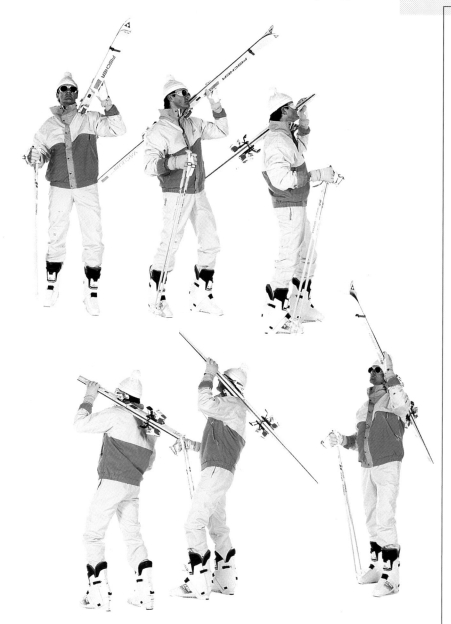

1·03 Skiing - admiring the view

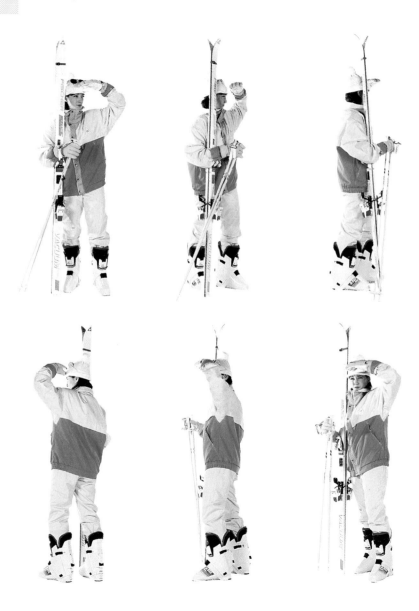

Golf - admiring the shot

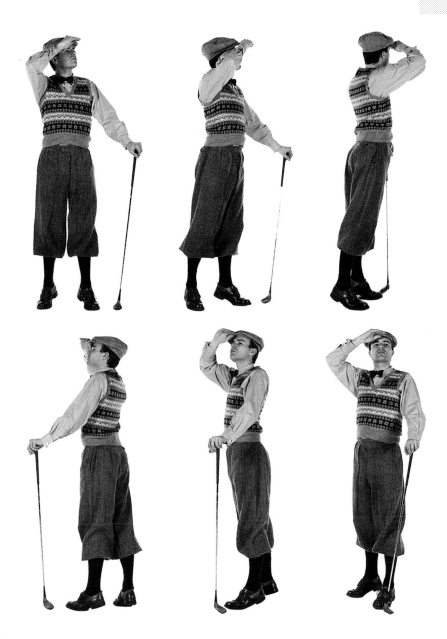

1·05

Golf - addressing the ball

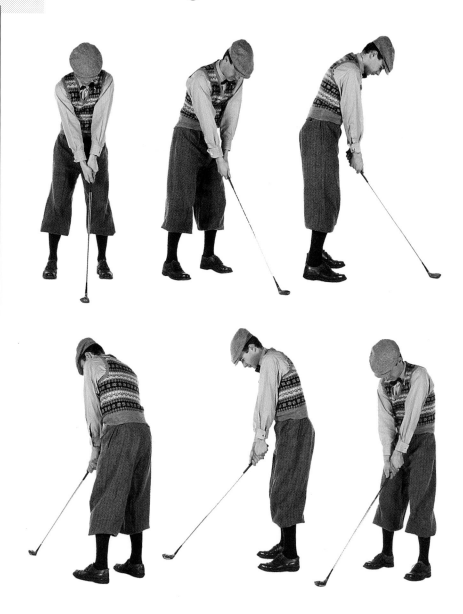

Golf - backswing

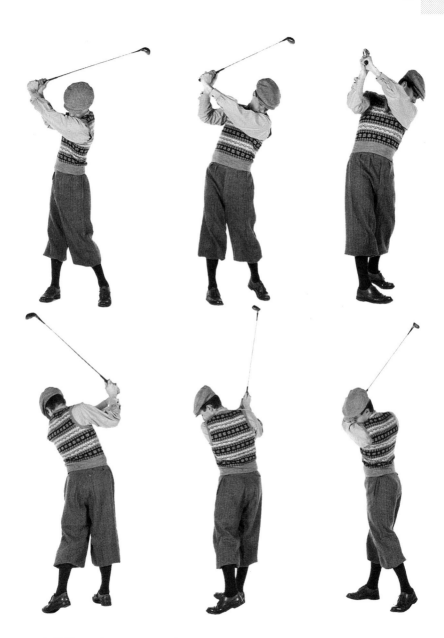

1·07 Tennis - ready to receive

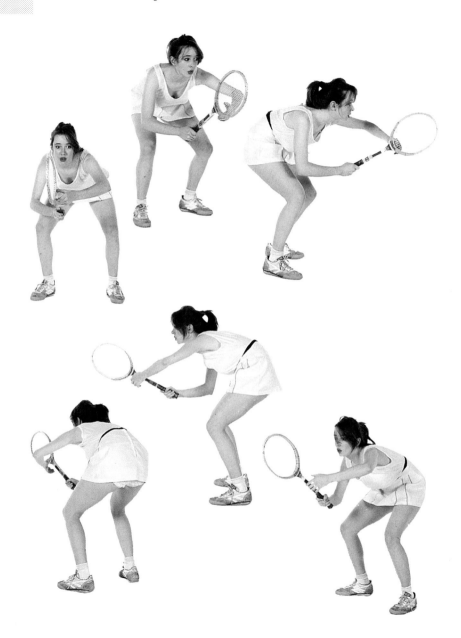

Tennis - forehand drive 1·08

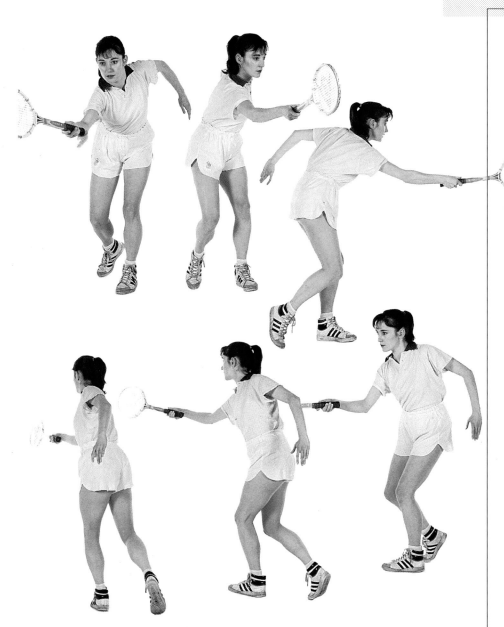

1·09 Badminton - smash

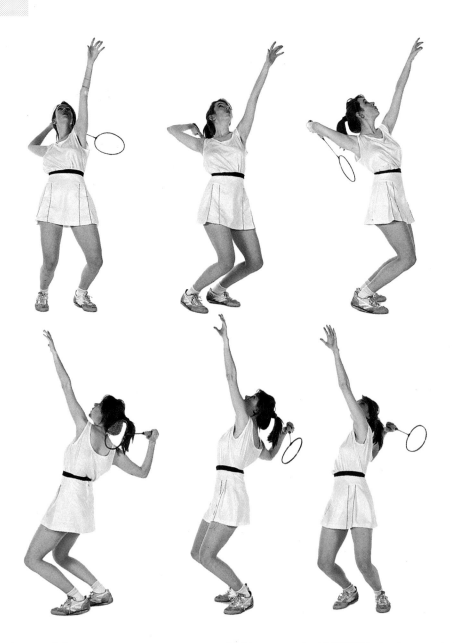

Squash - forehand 1·10

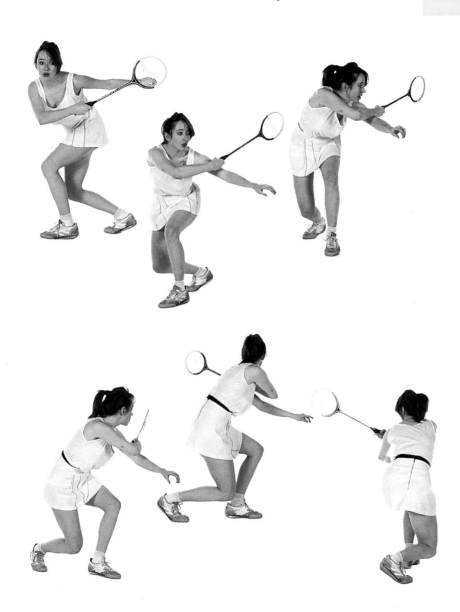

1.11 Squash - backhand

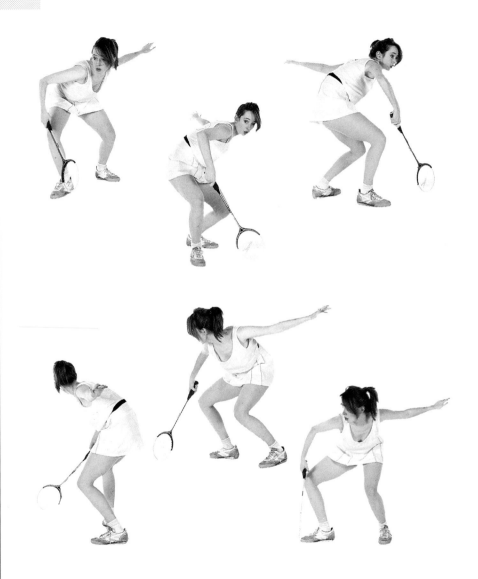

Cricket - defensive block 1·12

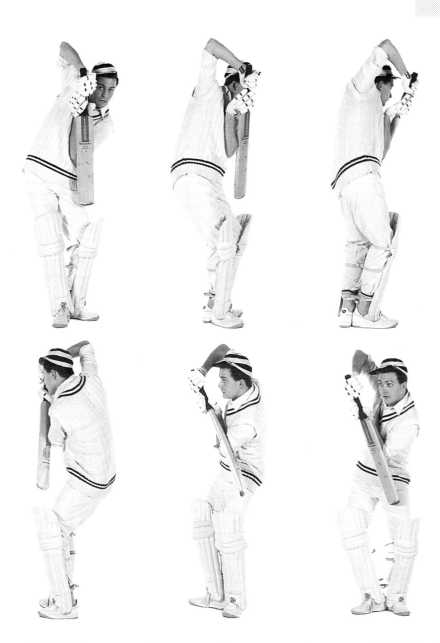

1·13

Cricket - waiting to bat

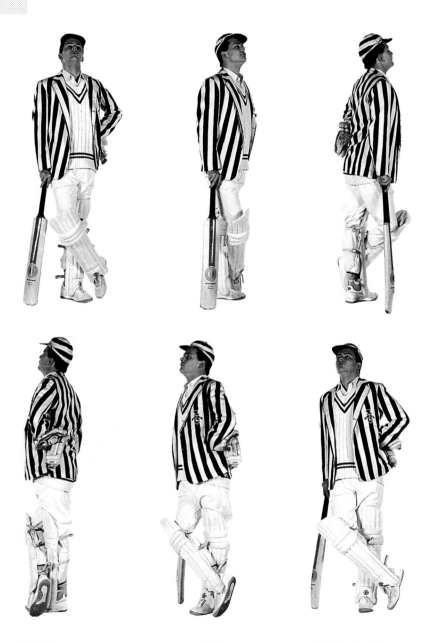

Throwing a ball

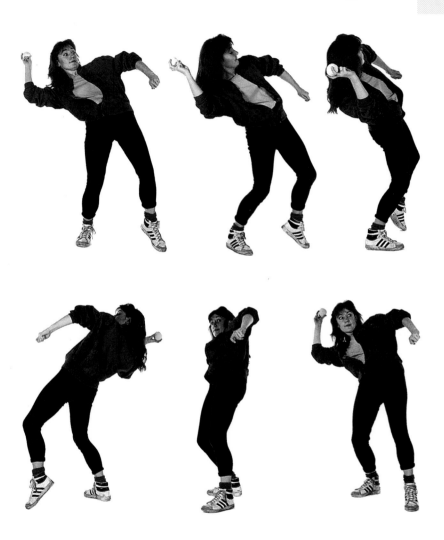

1·15 Tossing up a ball

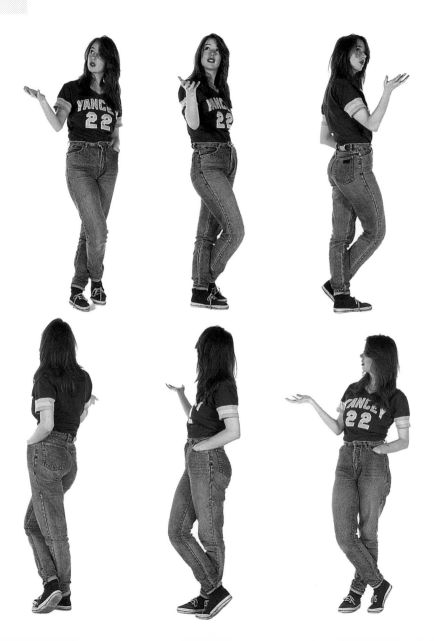

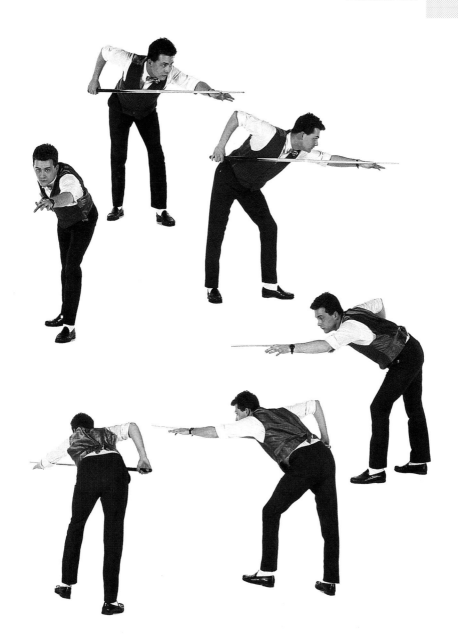

1·17 Bowling

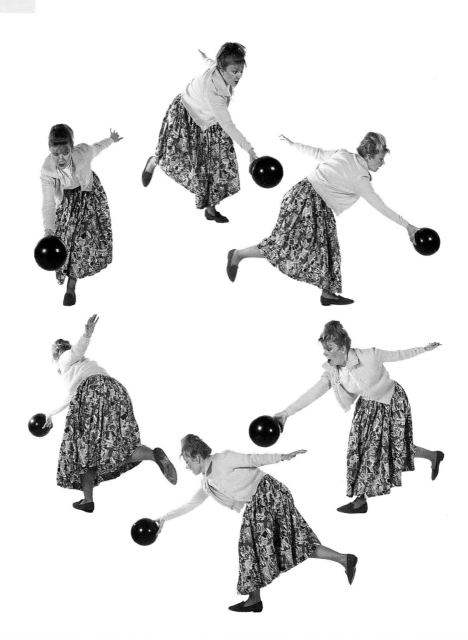

Soccer - throw-in

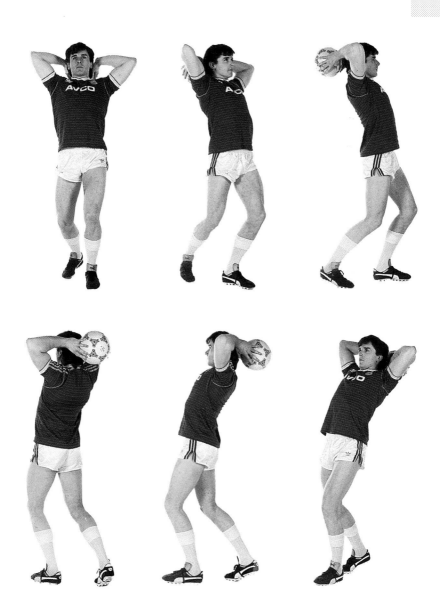

1·19 Running - sprinter on the block

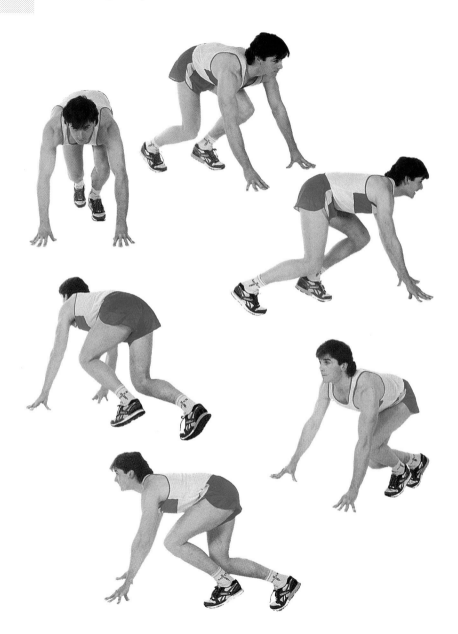

Rugby - passing

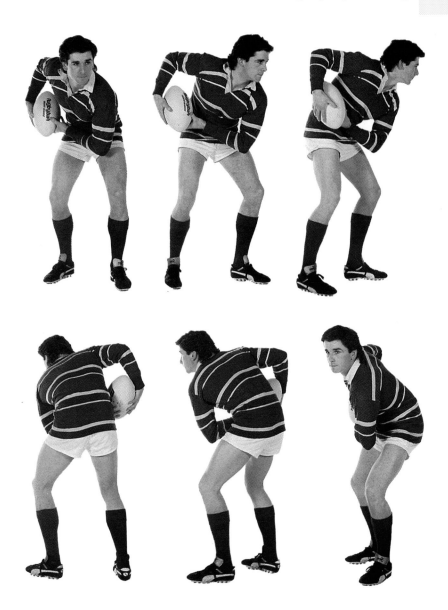

1·21 Rugby - drop kick

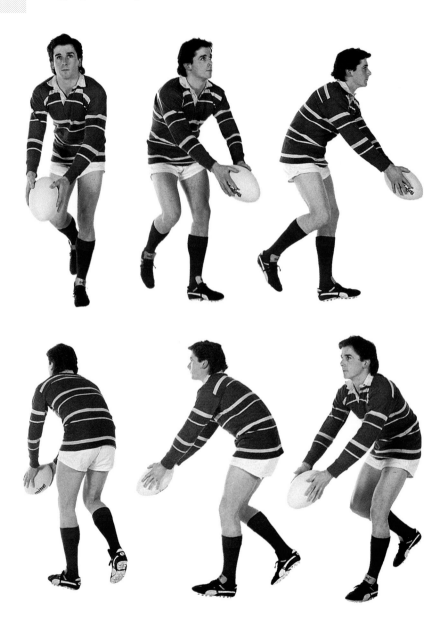

Basketball - dribbling 1·22

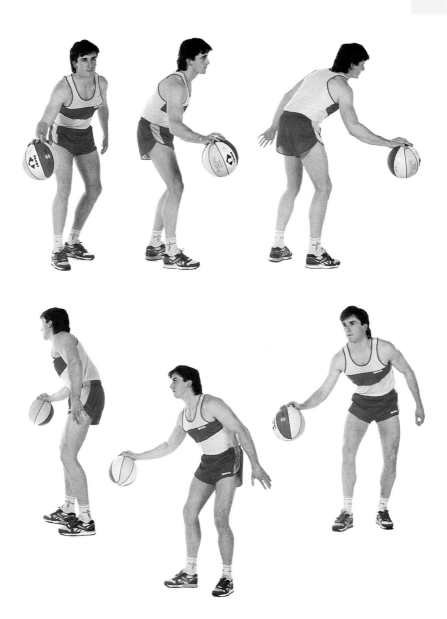

1·23

Basketball - shooting

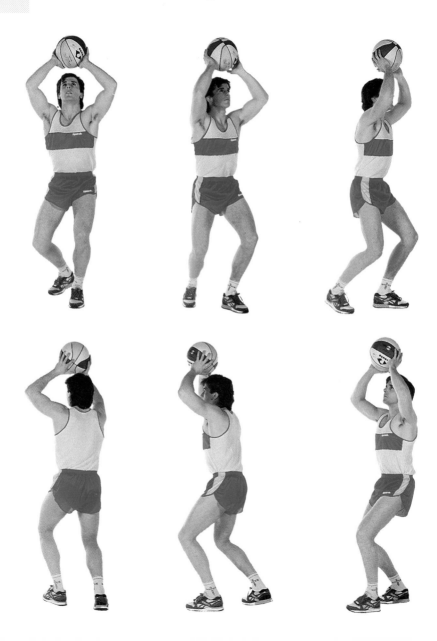

Boxing - classic guard 1·24

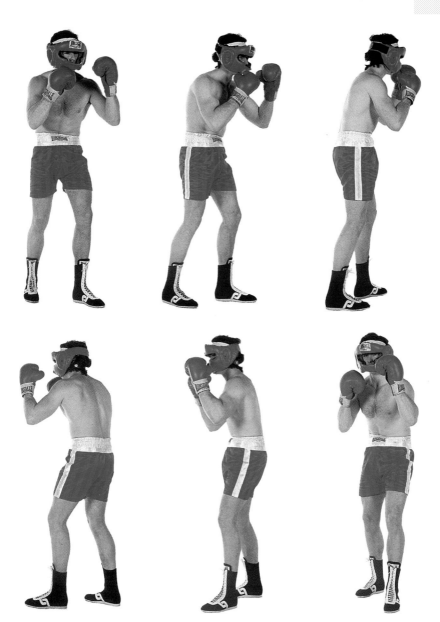

1·25 Boxing - jabbing

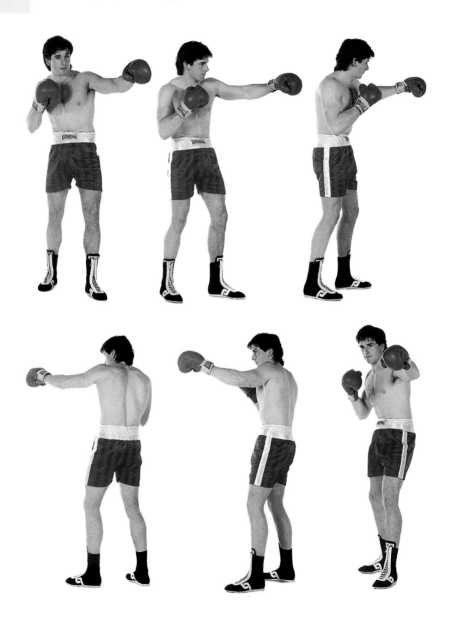

Boxing - the winner

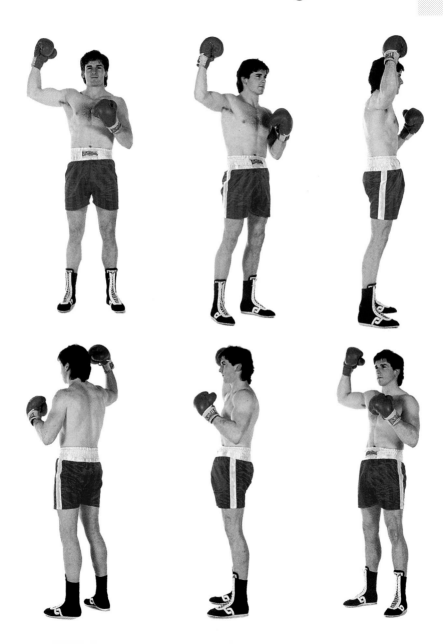

1·27 Weightlifting - one-arm dumbbell

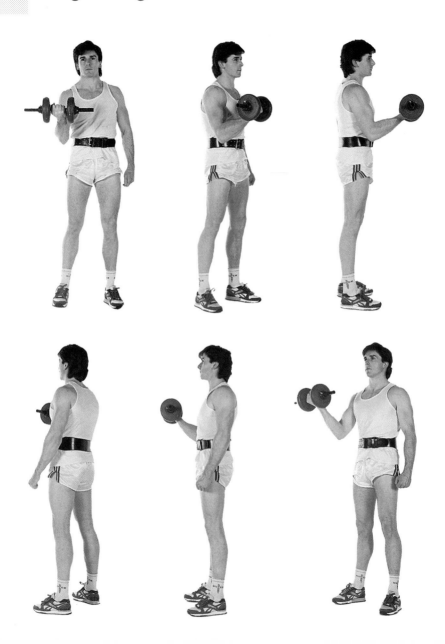

Weightlifting - bar under chin　　1·28

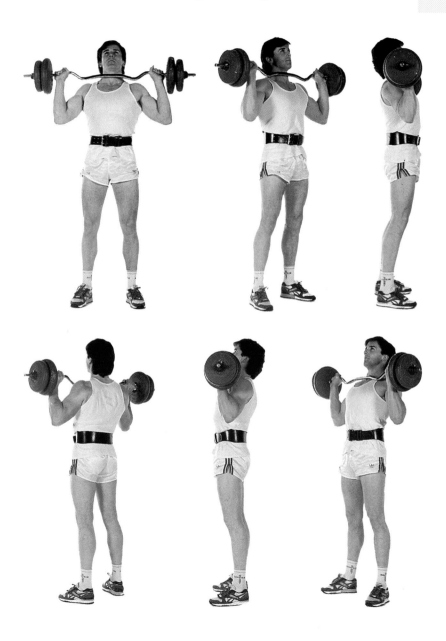

1·29 Skipping rope

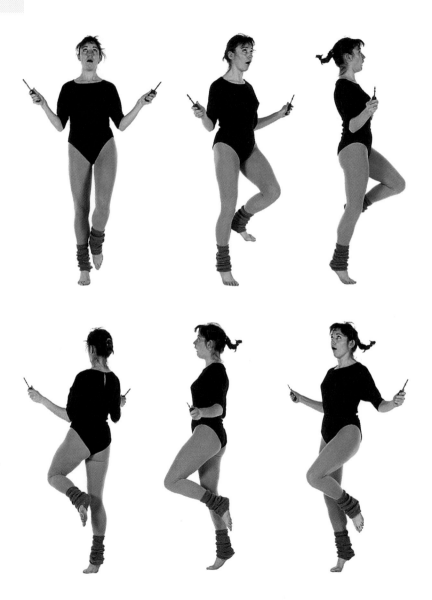

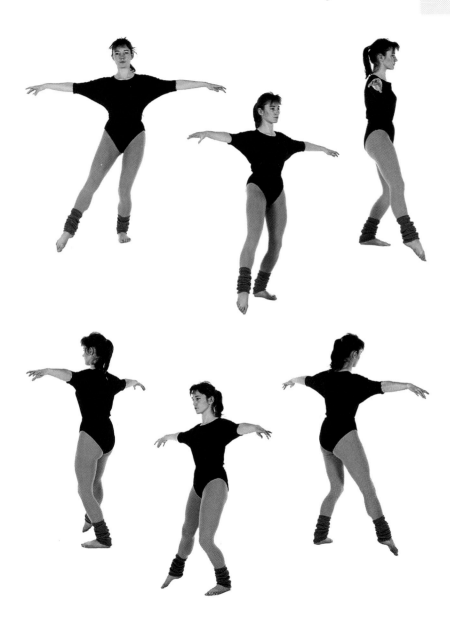

1·31 Gymnastics - headstand

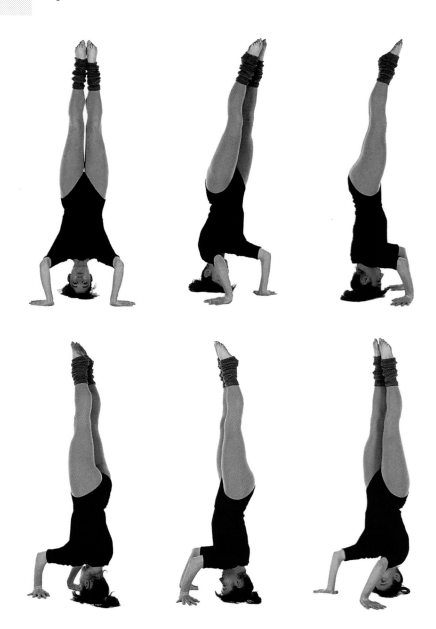

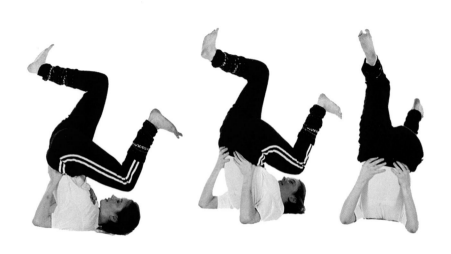

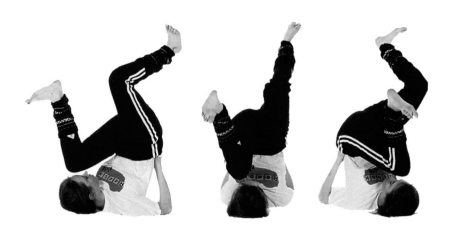

1·33 Exercising - toe touch

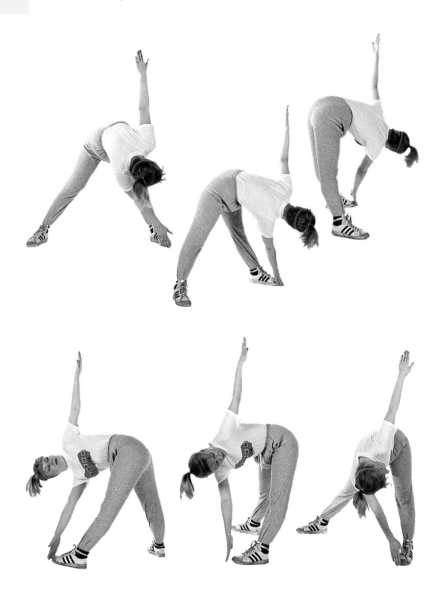

Exercising - end of the workout 1·34

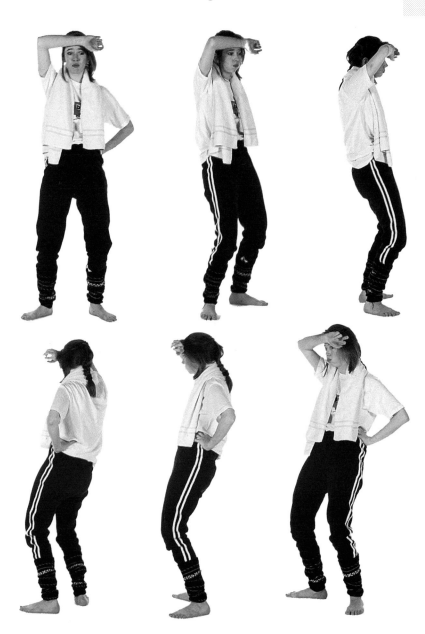

1·35 Exercising - stretching

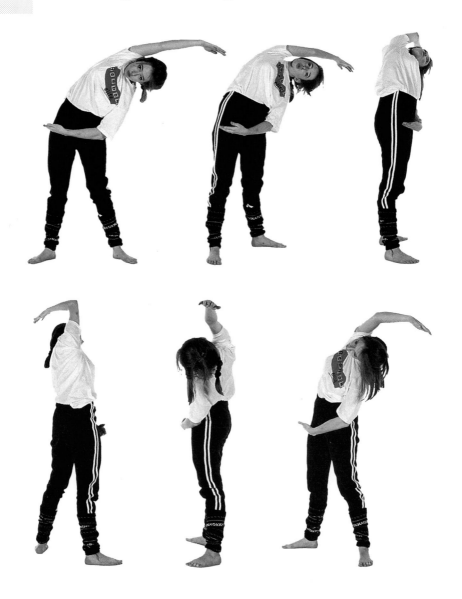

Yoga 1·36

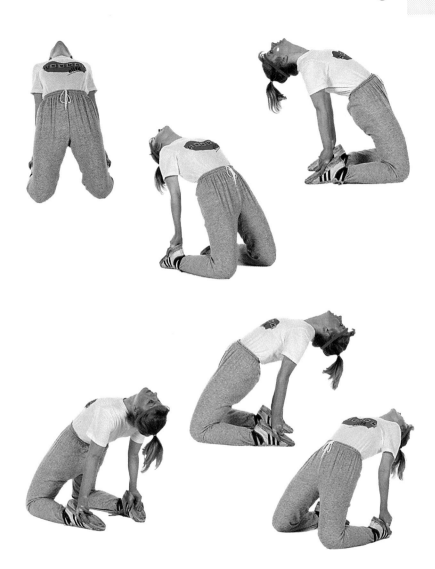

1·37 Yoga

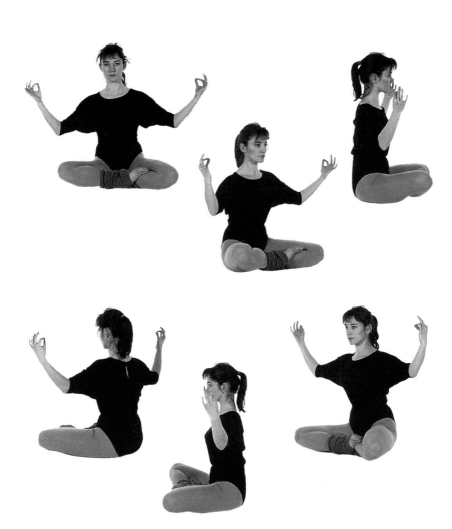

Skateboarding

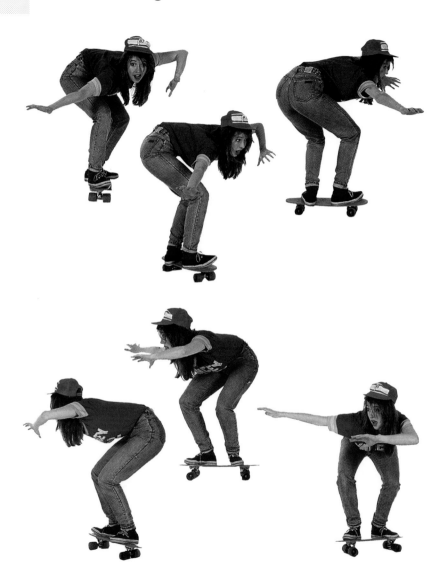

Walking the dog 1·40

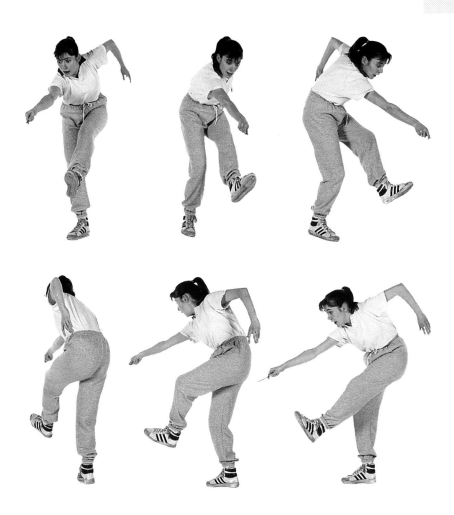

1·41 **Walking with stick**

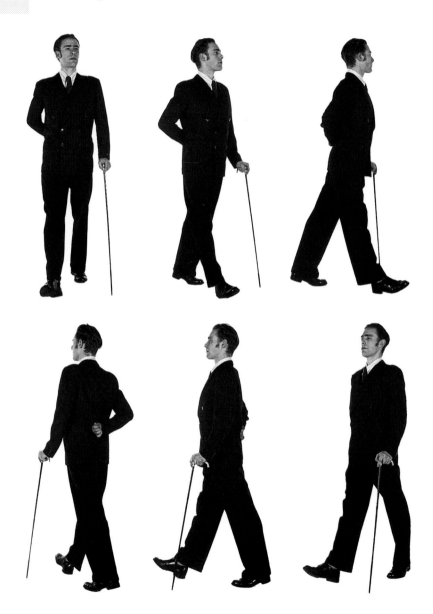

Playing cards 1·42

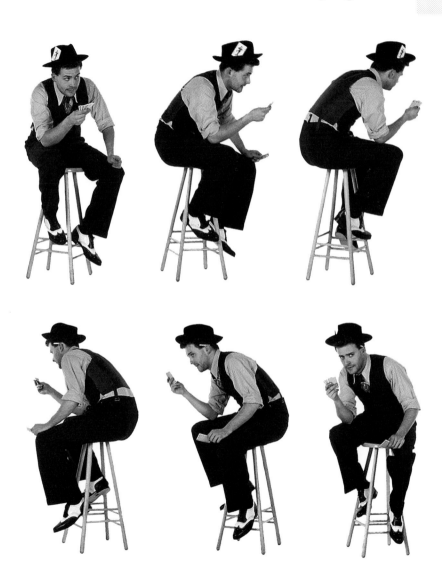

1·43 Artist painting

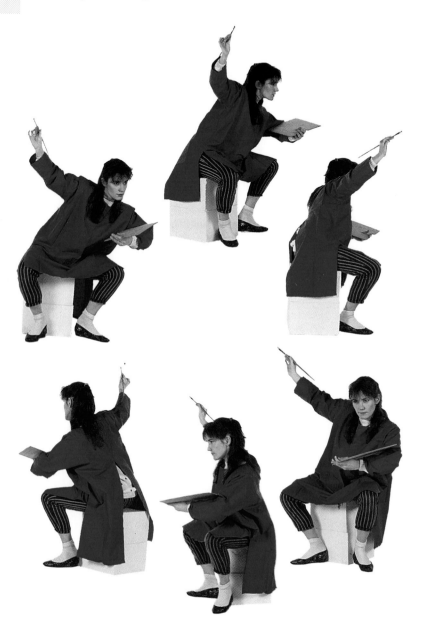

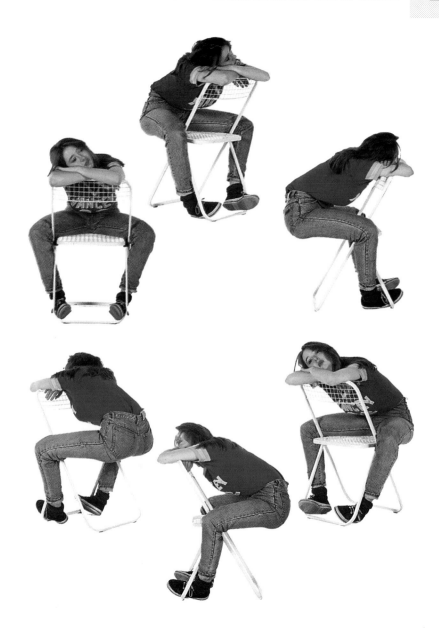

2·02 In a chair doing the crossword

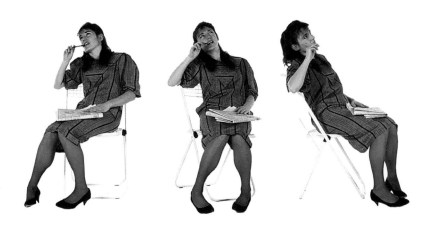

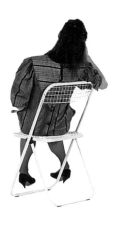

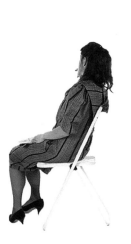

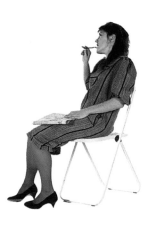

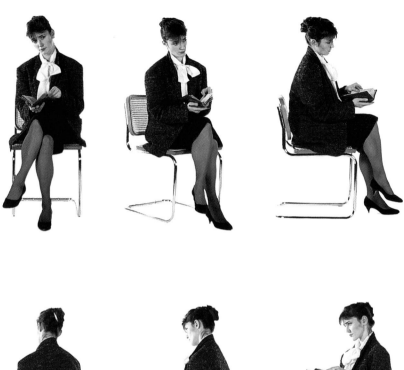

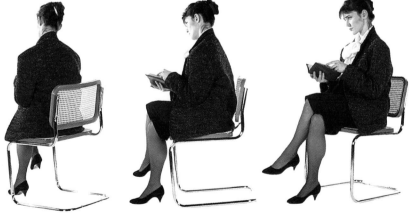

2·04 Sideways in a chair

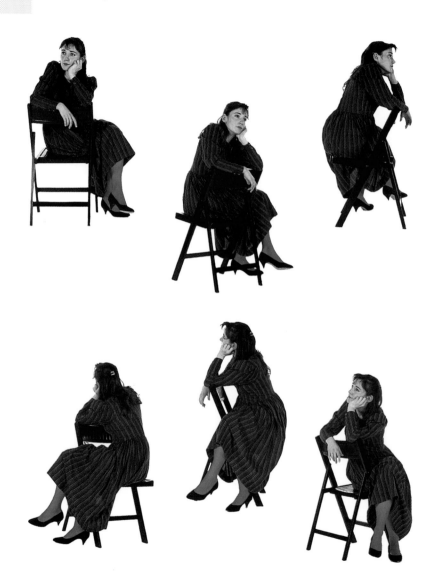

Kneeling on a chair and talking on the phone

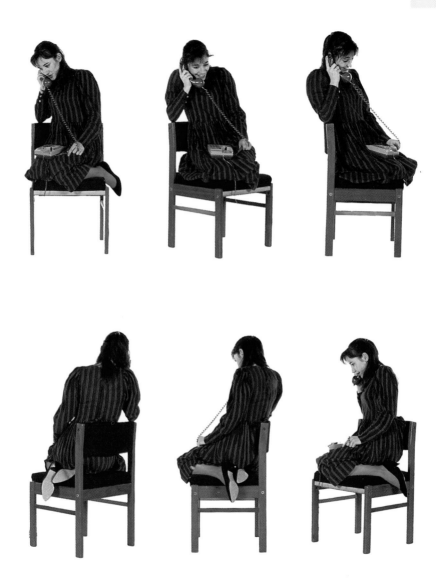

2·06 On a bar stool

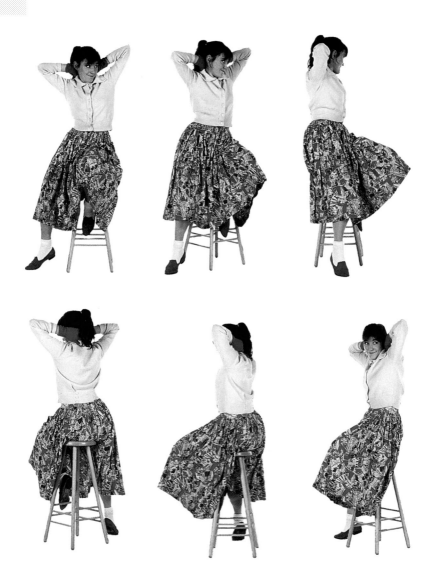

Priest asleep in a rocking chair

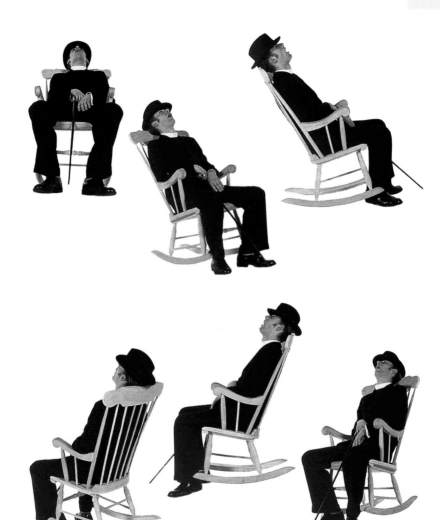

2·08 On the floor thinking

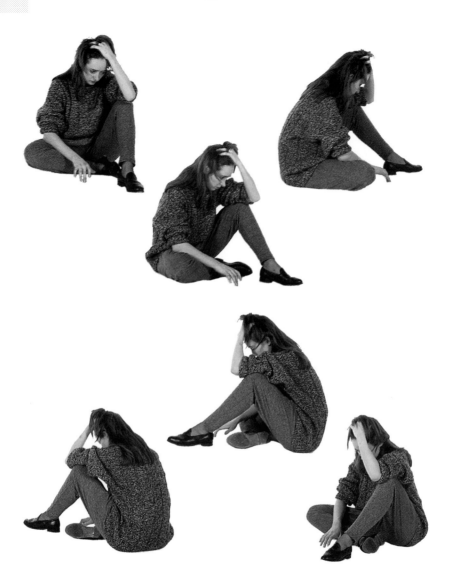

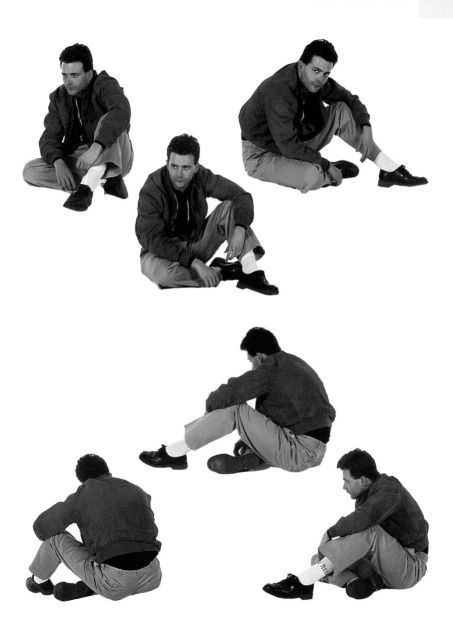

3·01 **Couple kissing**

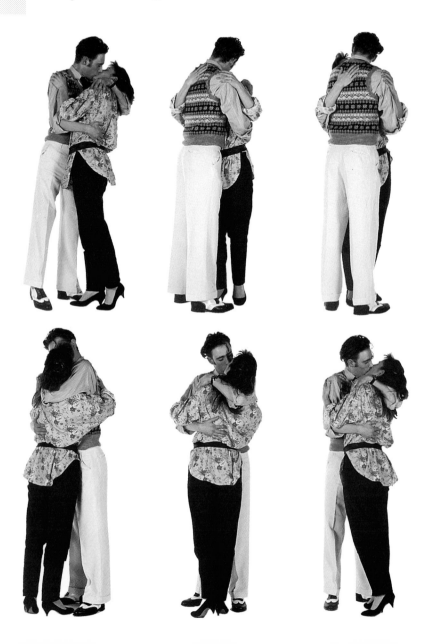

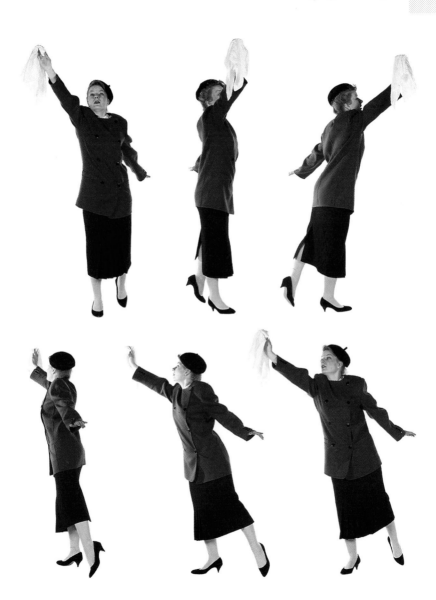

3·03 Crying into handkerchief

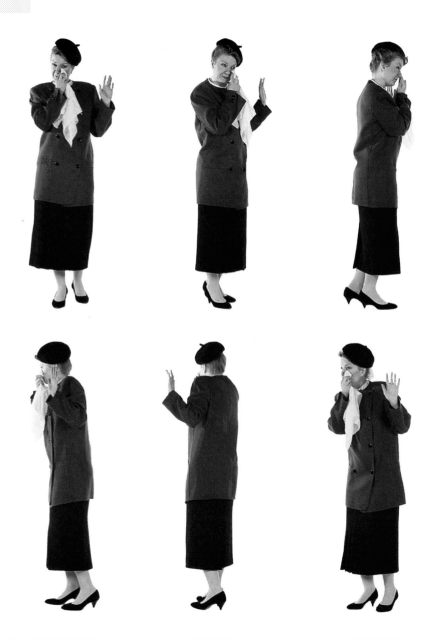

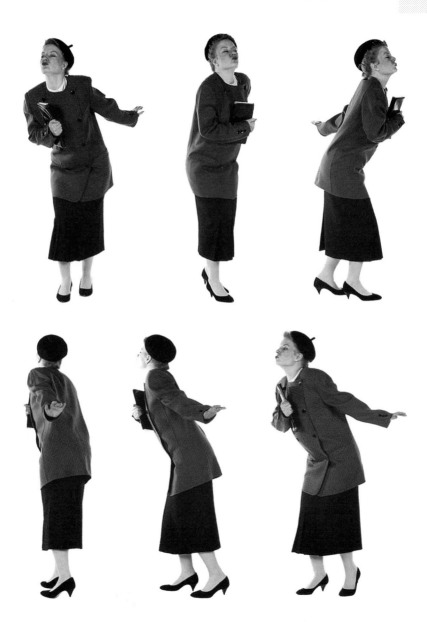

3·05 GI greeting his girl

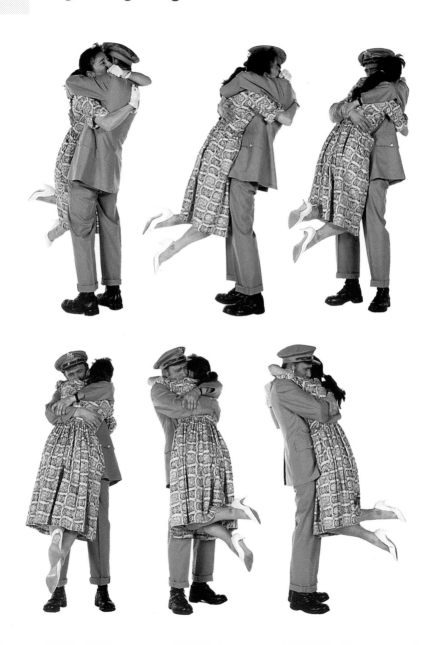

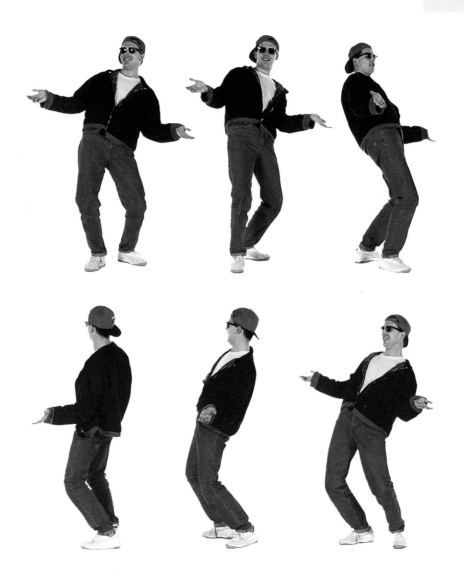

3·07 Couple sitting

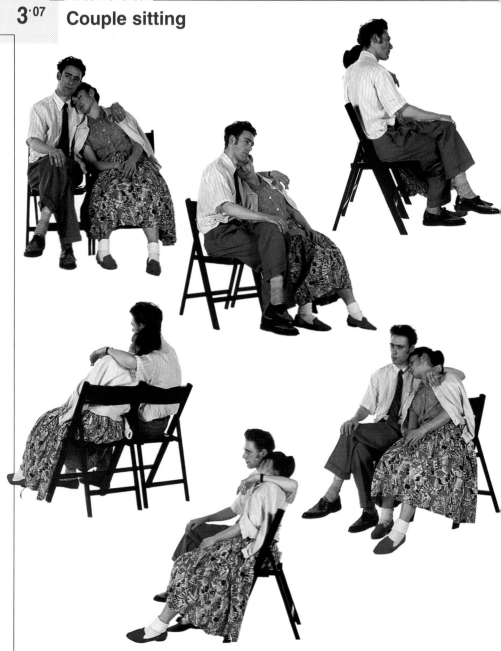

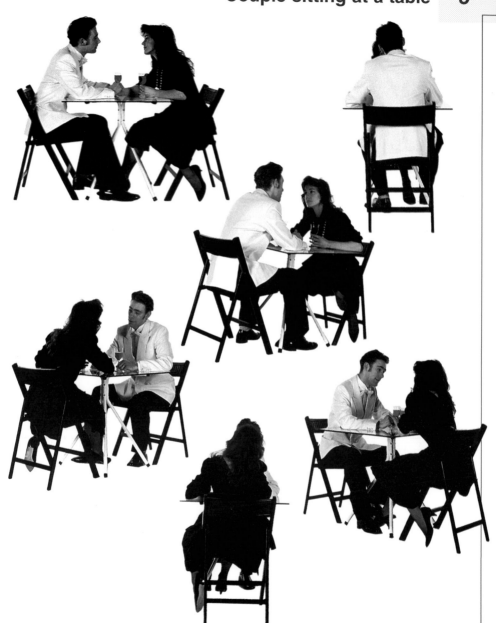

3·09 ## Bully threatening someone

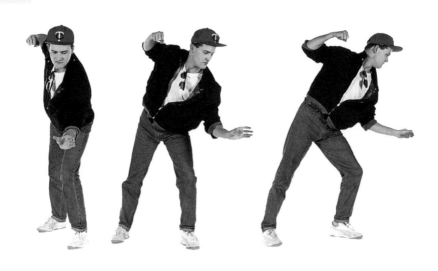

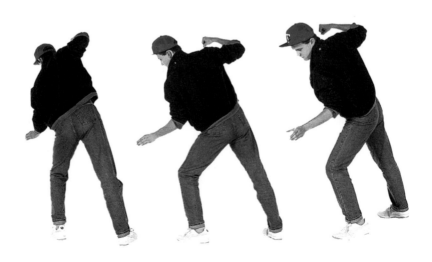

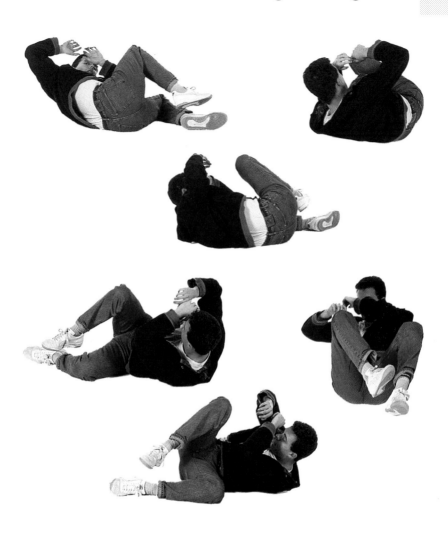

3·11 Taking the lady home

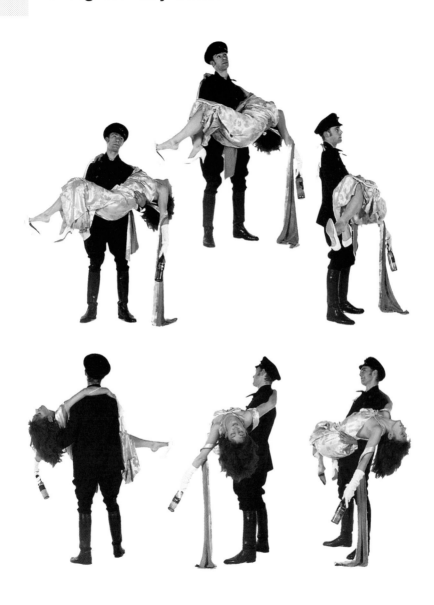

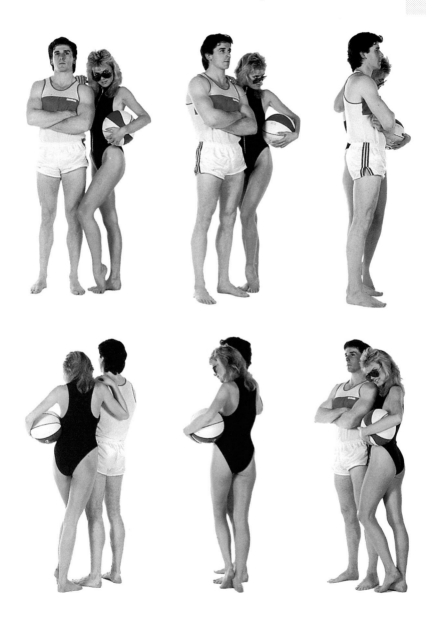

3·13 **Praying**

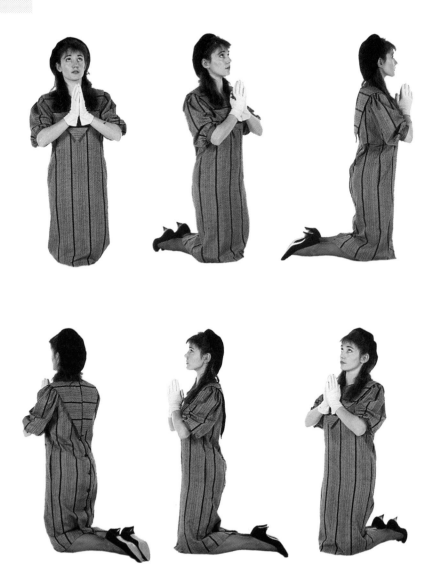

New York policeman - stop! 4·01

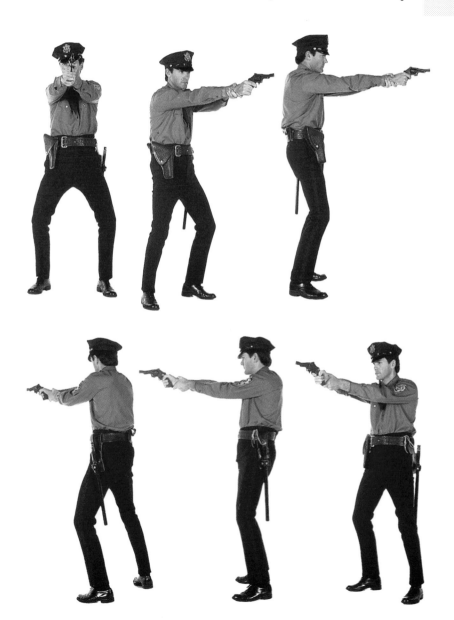

4·02 New York policeman directing traffic

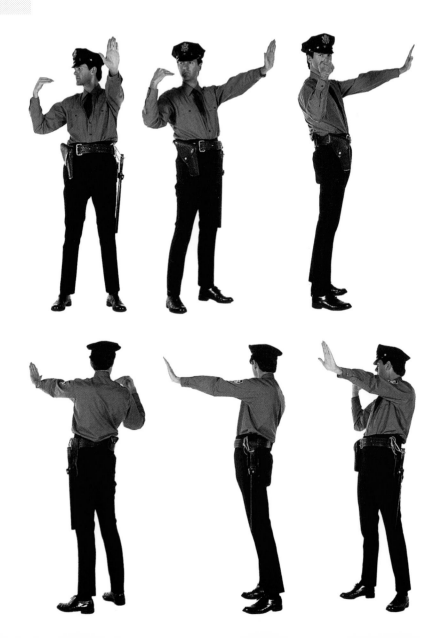

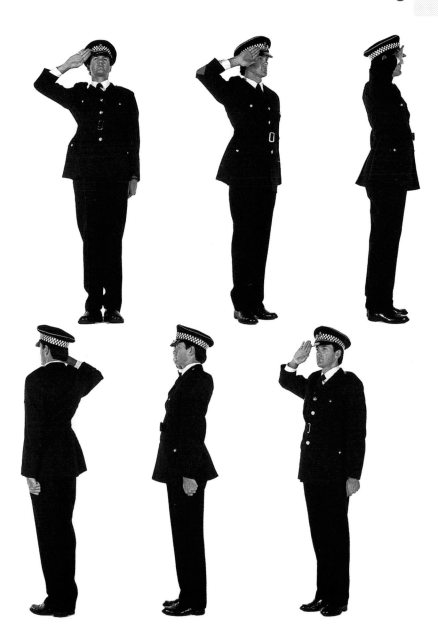

4·04 Gangster with violin case

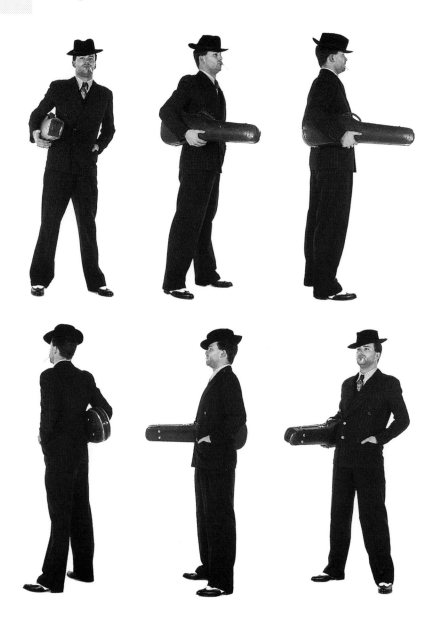

Hailing a taxi 5·01

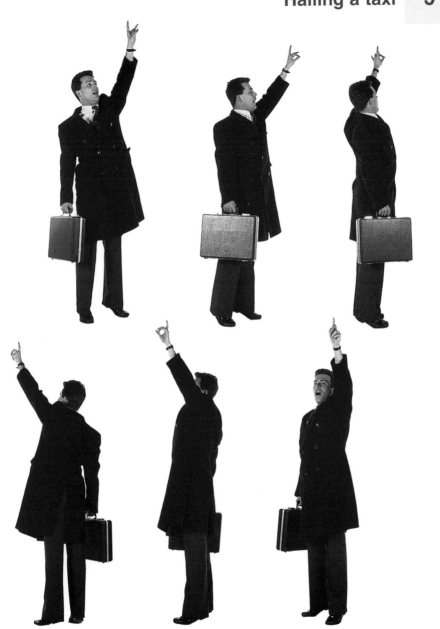

5·02 Running and looking at watch

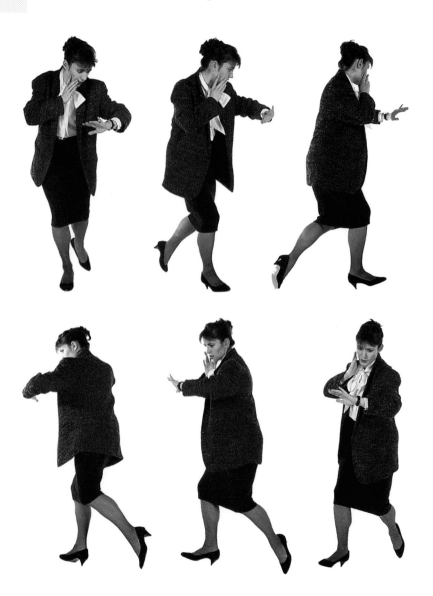

Opening an umbrella

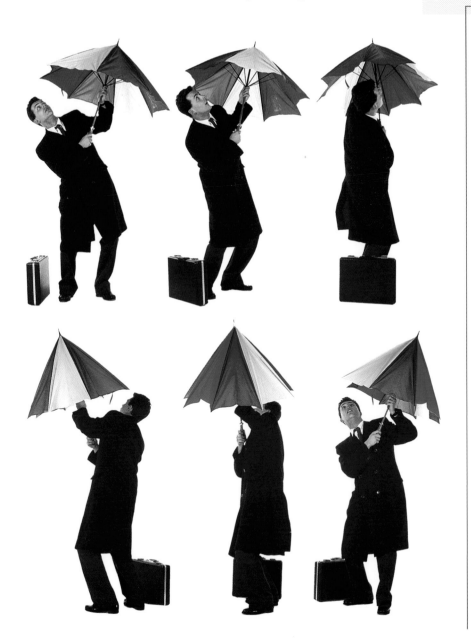

5·04 # Standing under an umbrella

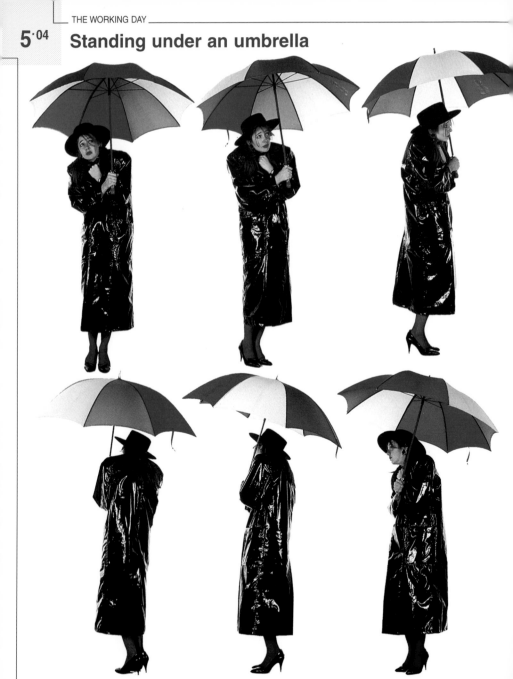

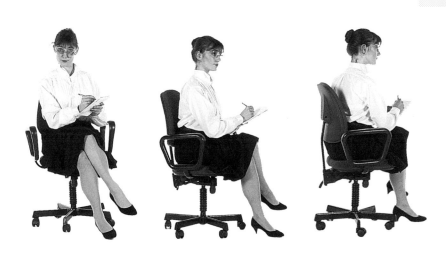

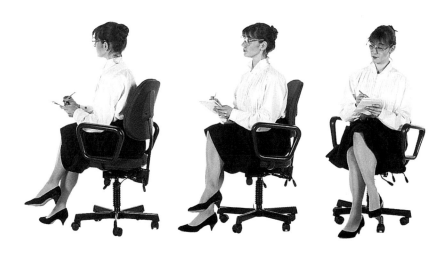

5·06 Commuting

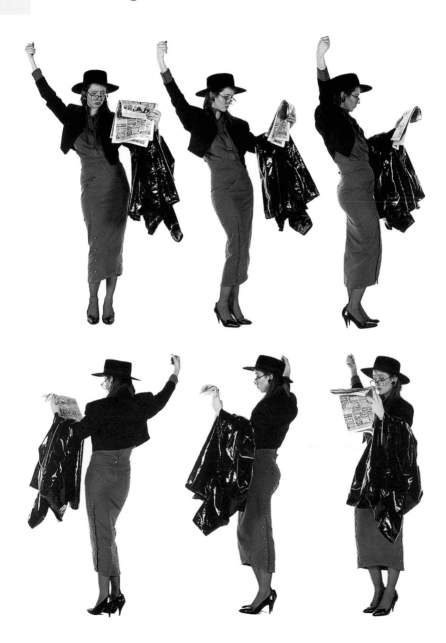

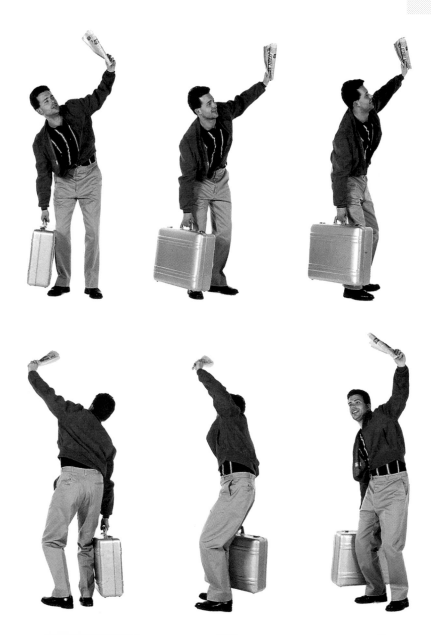

5·08 On the phone

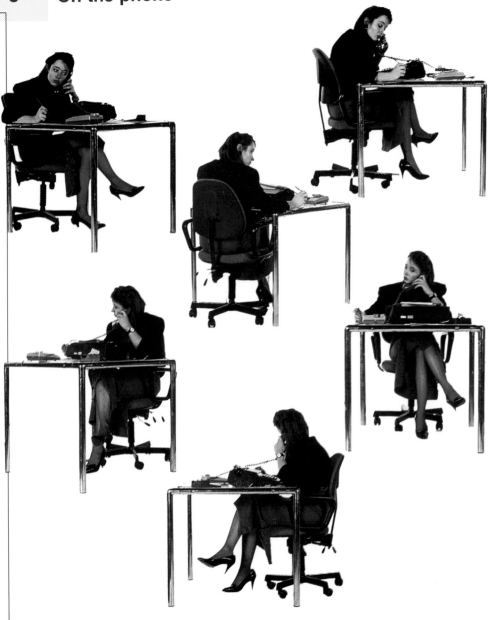

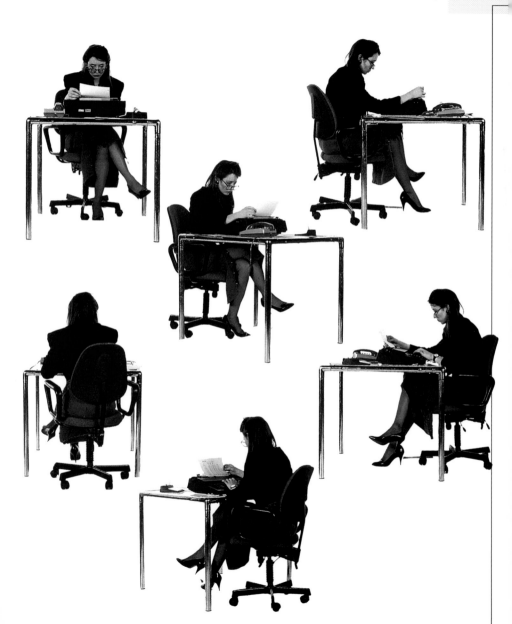

6·01 Stack of boxes

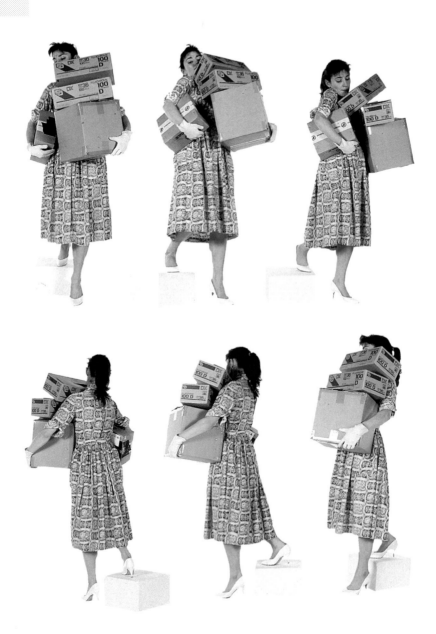

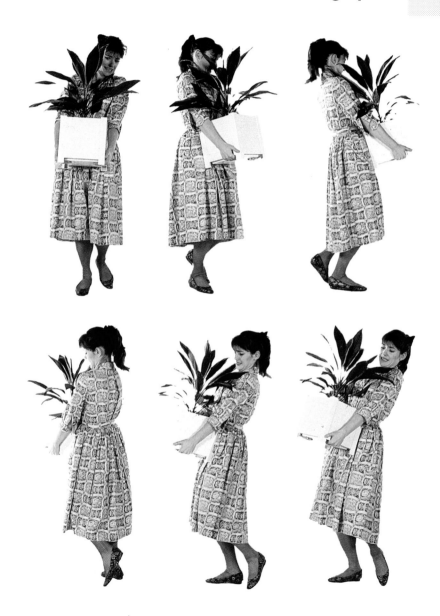

6·03 Step ladder

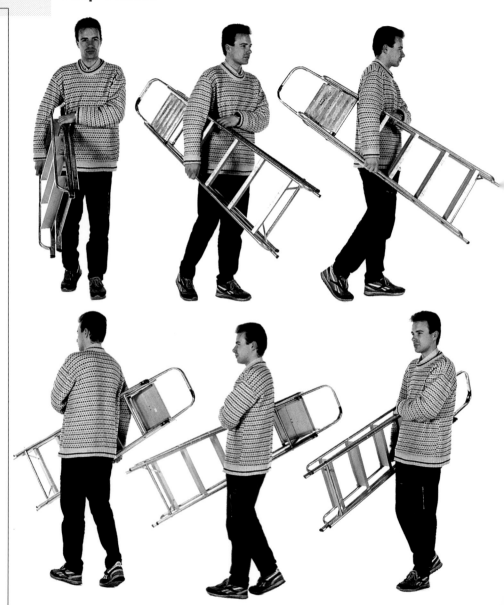

Smelly socks 6·04

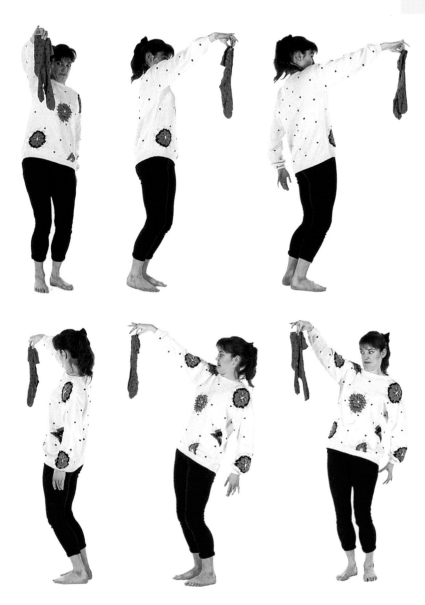

7·01 **Painting with a roller**

Leaning on a broom

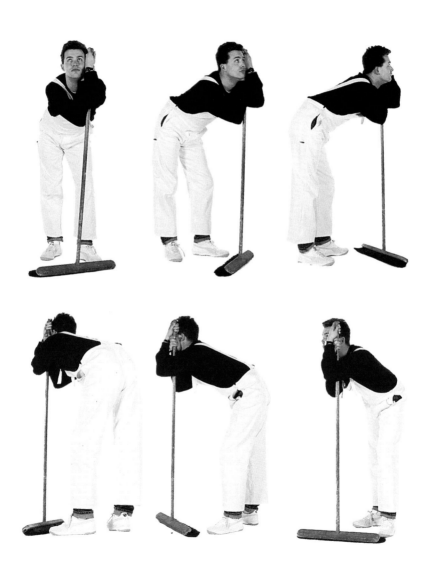

7·03 Sawing

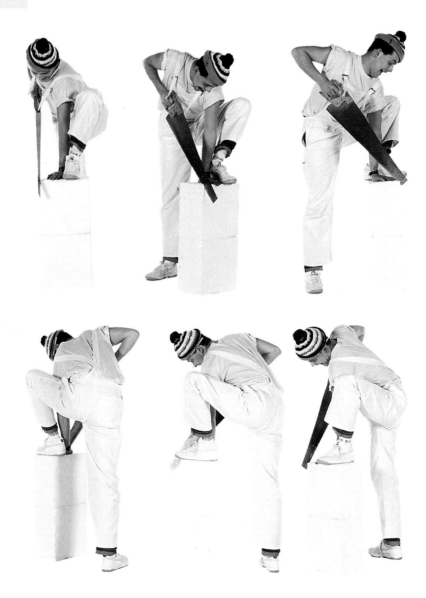

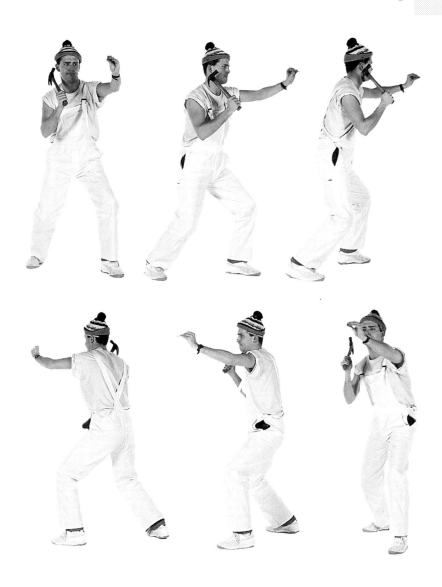

7·05 Painting with a brush

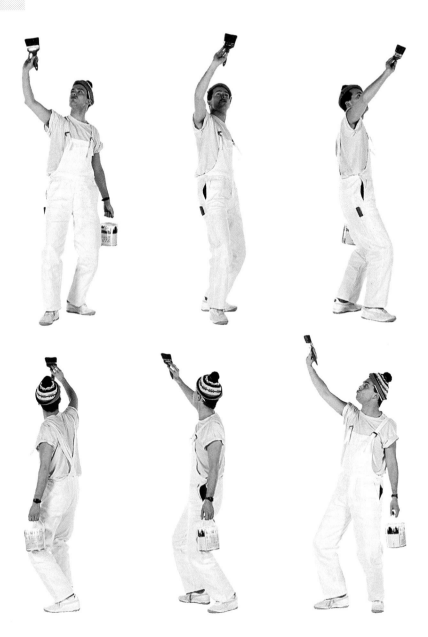

Eating sandwiches and drinking tea $8^{.01}$

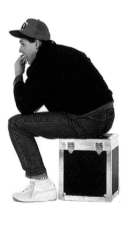
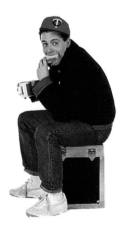
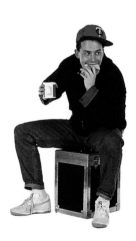

8·02 Drinking from a teacup and saucer

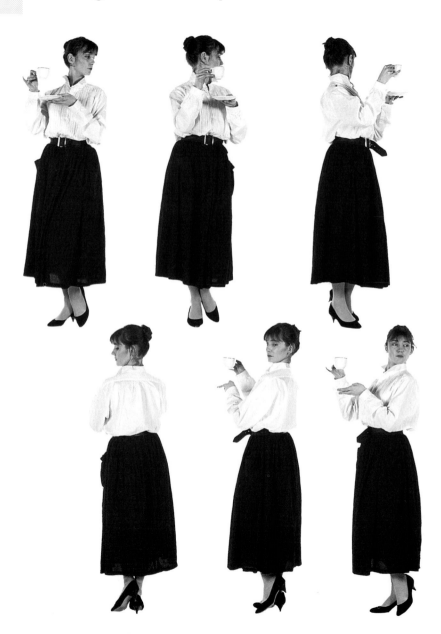

Priest with tea and biscuits

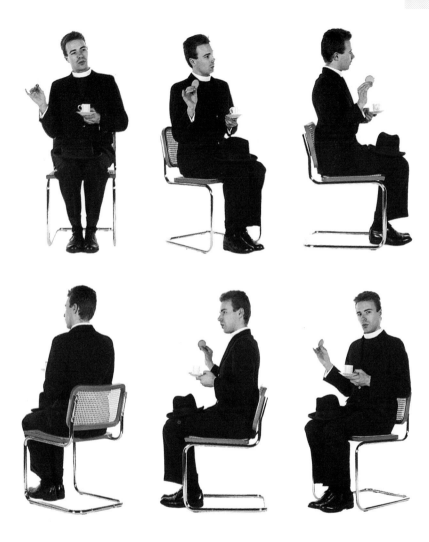

8·04 Waitress with tray

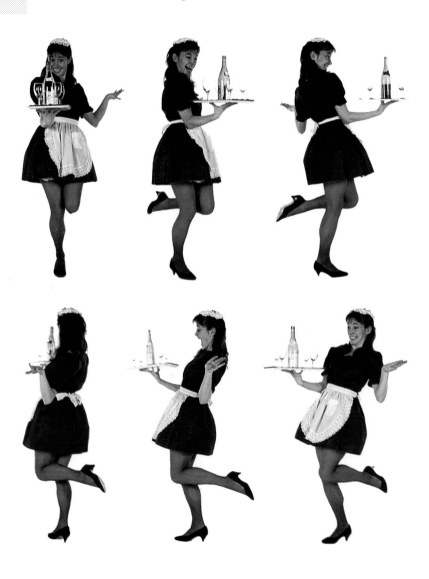

Rock and roll dancing

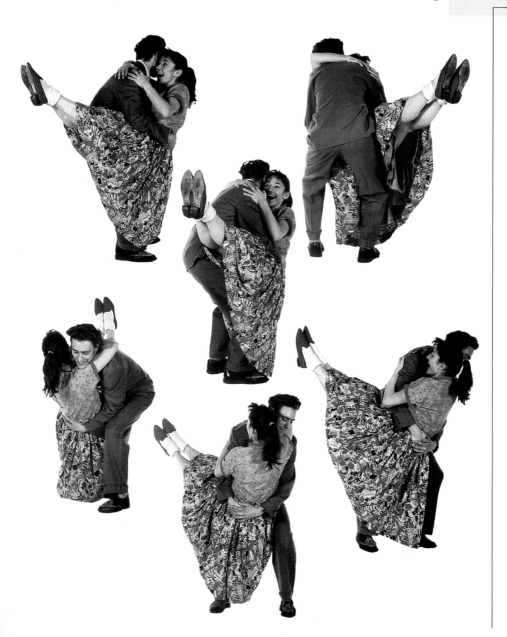

Ballroom dancing - quickstep

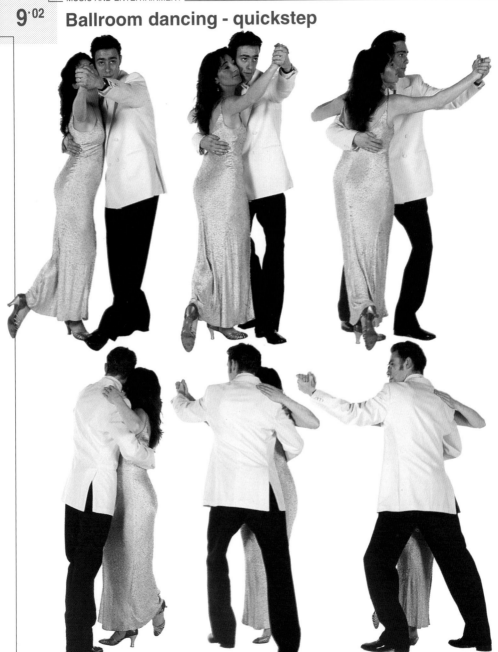

Ballroom dancing - waltz

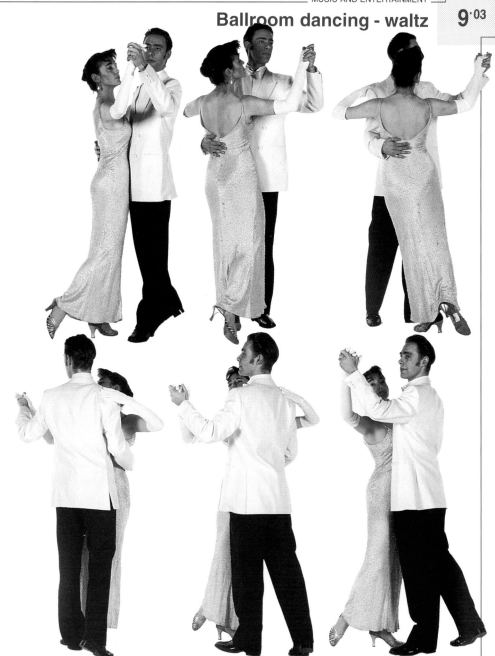

9·04 Ballroom dancing - tango

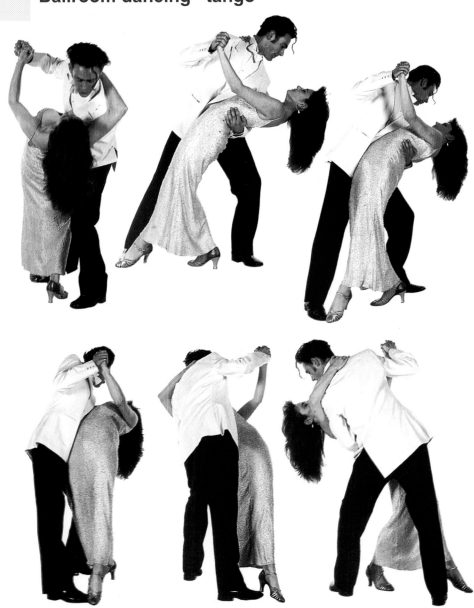

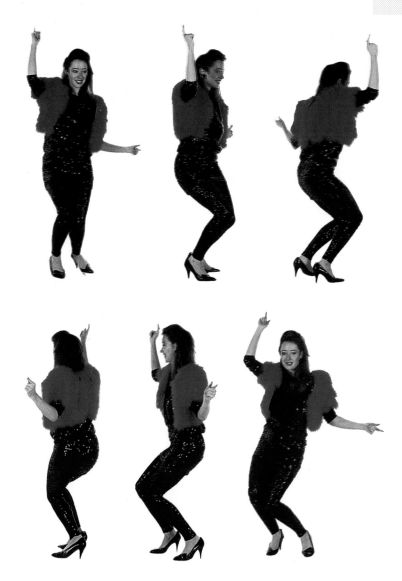

9·06 Conducting - vivace

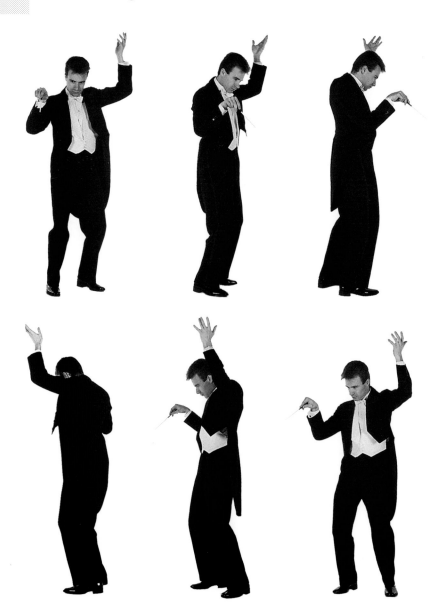

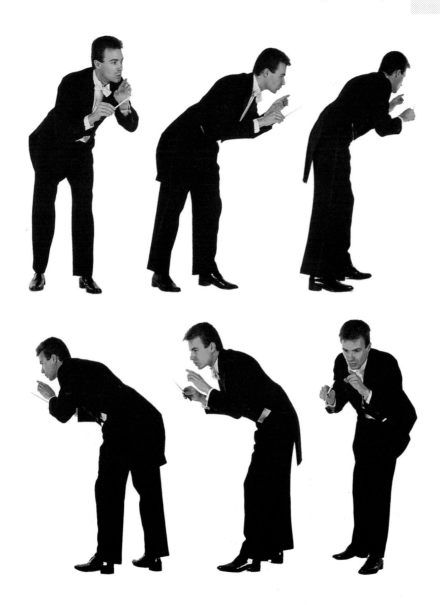

9·08 Playing the clarinet

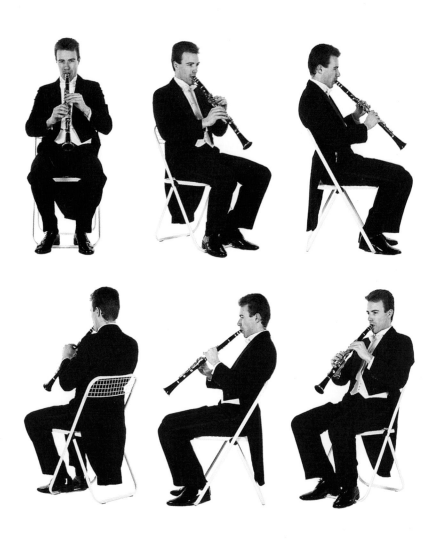

Playing the double bass

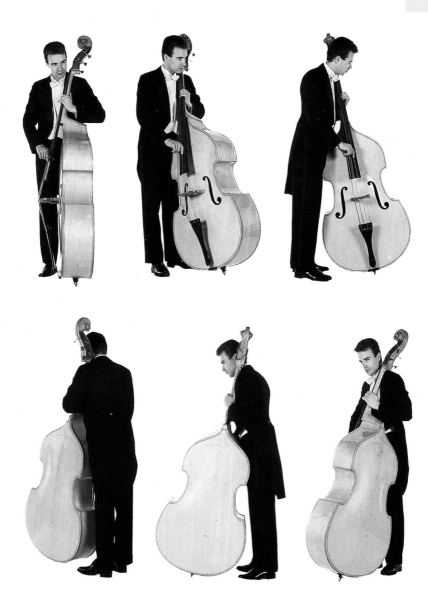

Playing the violin

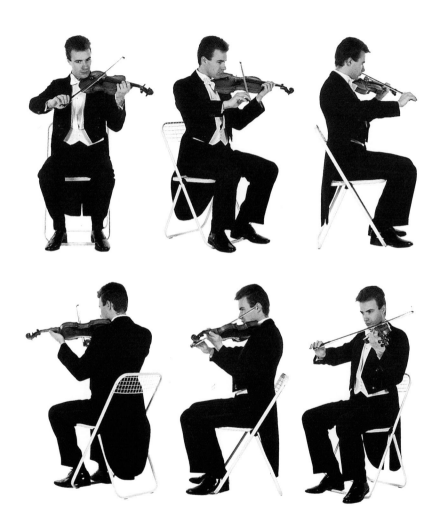

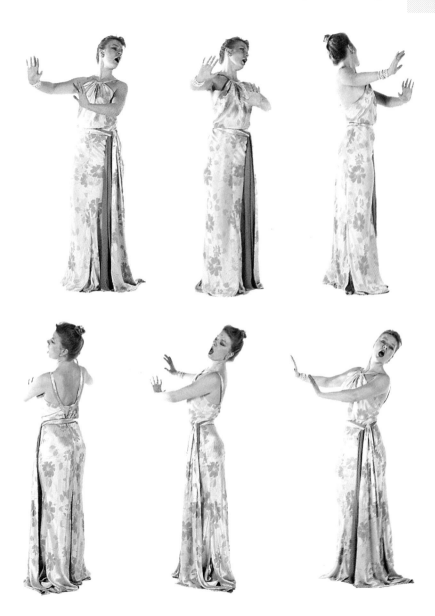

9·12 Rock singer

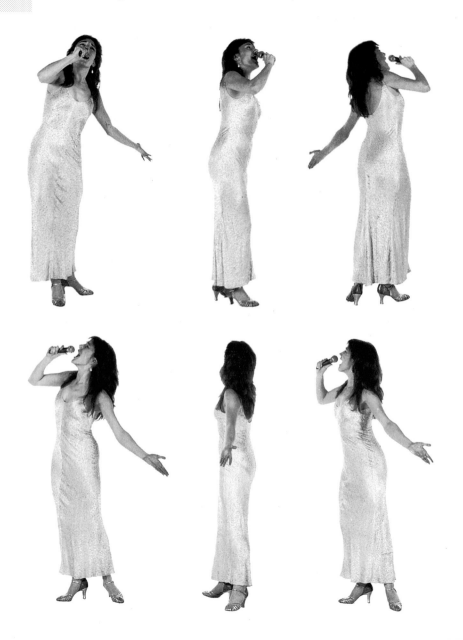

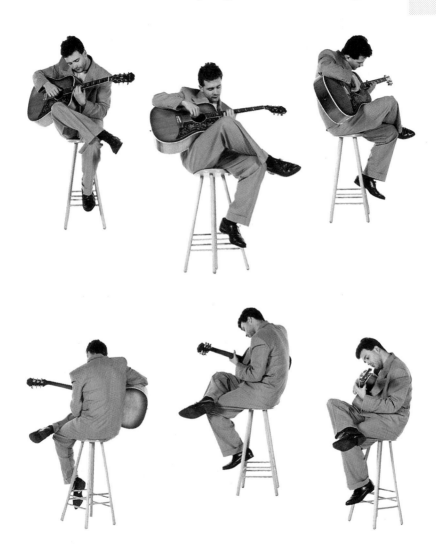

9·14 Playing the electric guitar

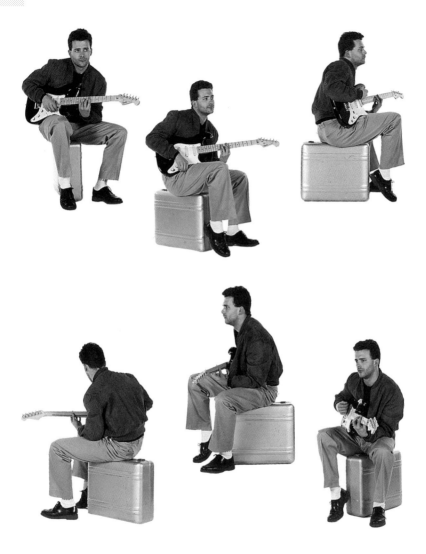

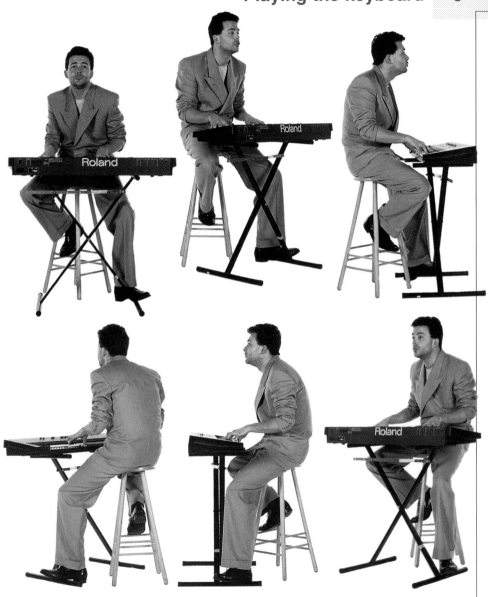

9·16 Jazz trumpeter

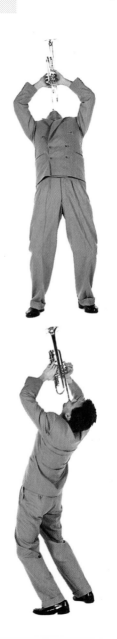
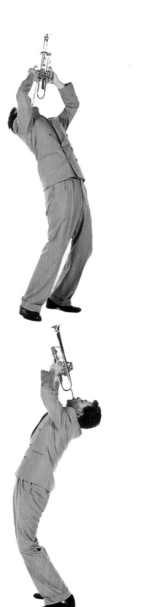
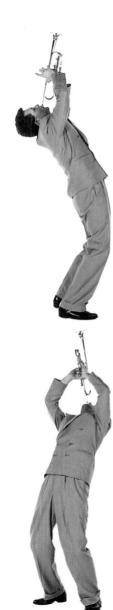

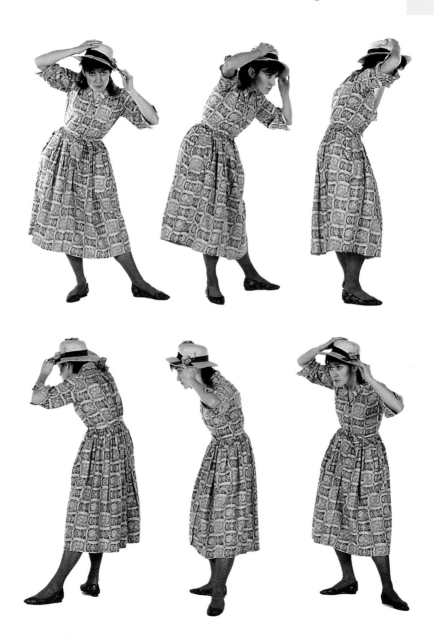

Putting on a jacket

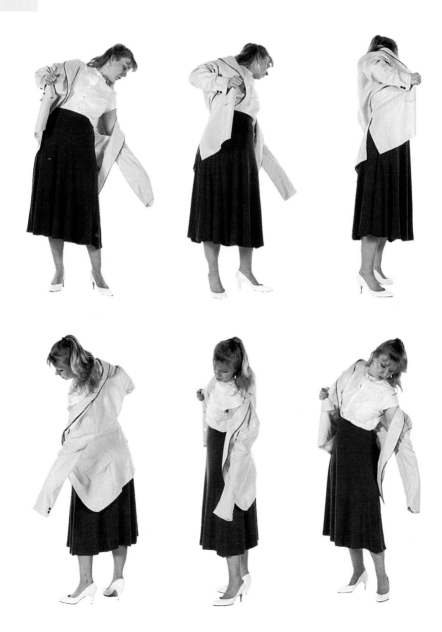

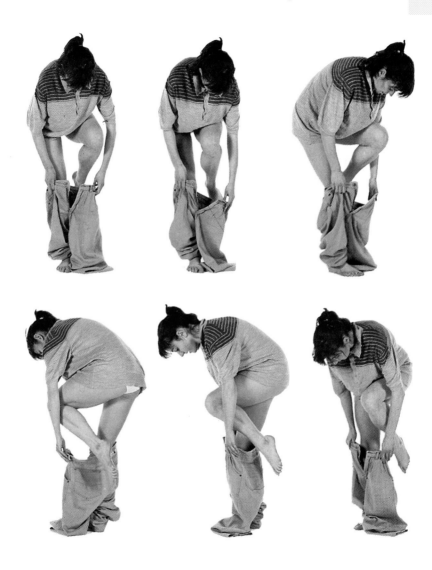

10·04 Putting on socks

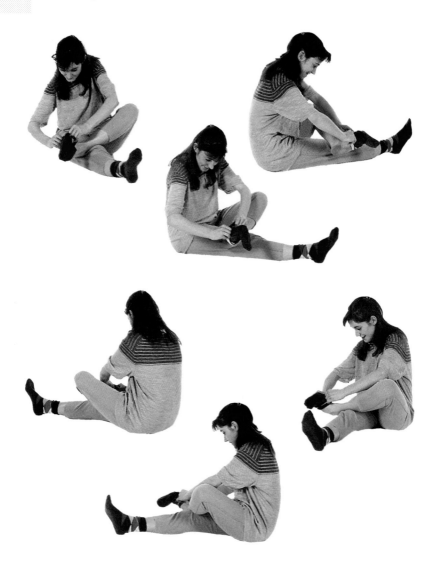

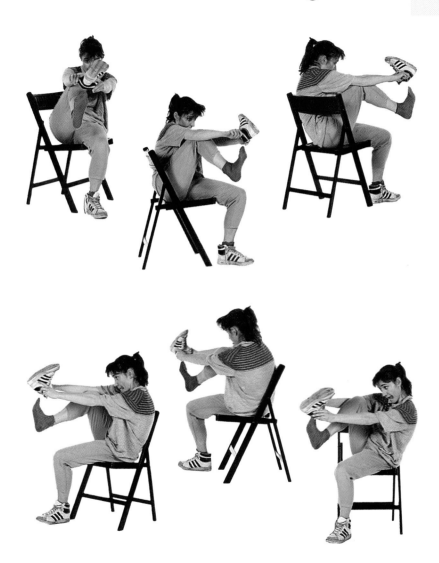

10·06 Taking off boots

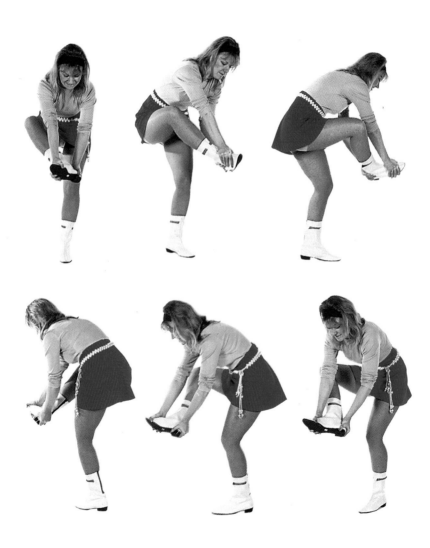

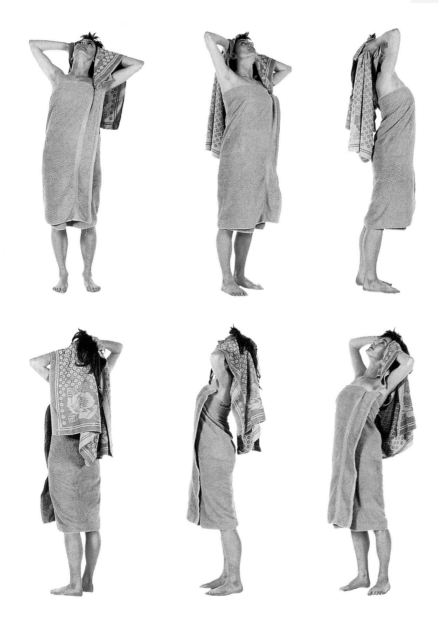

11·01 **Pin-up**

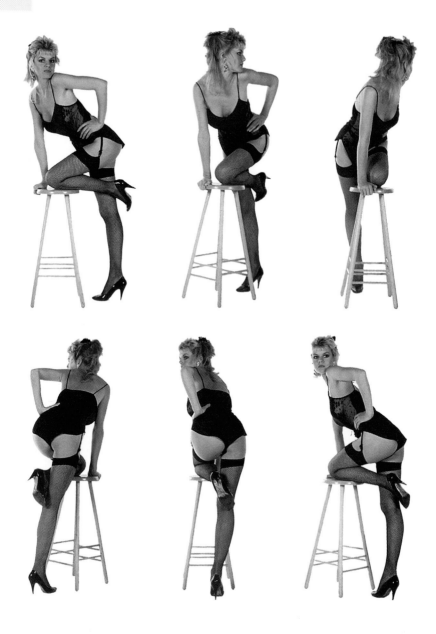

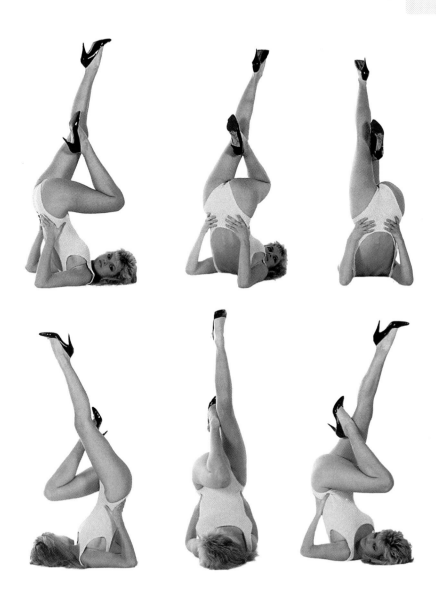

Pin-up

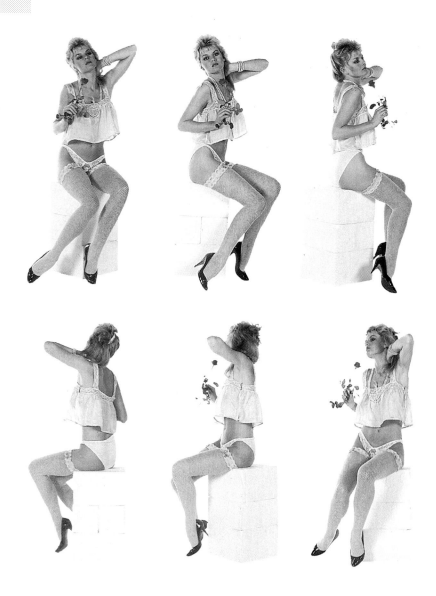

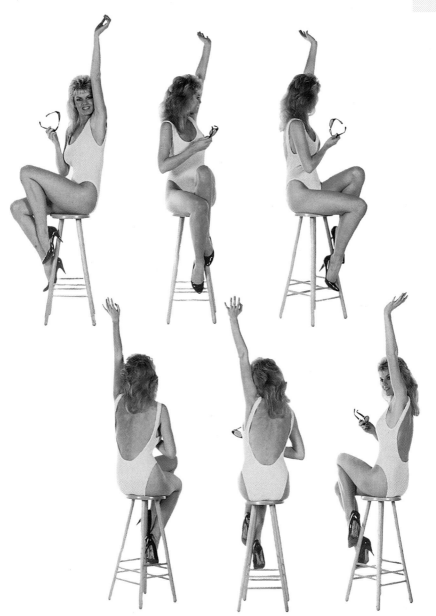

Pin-up

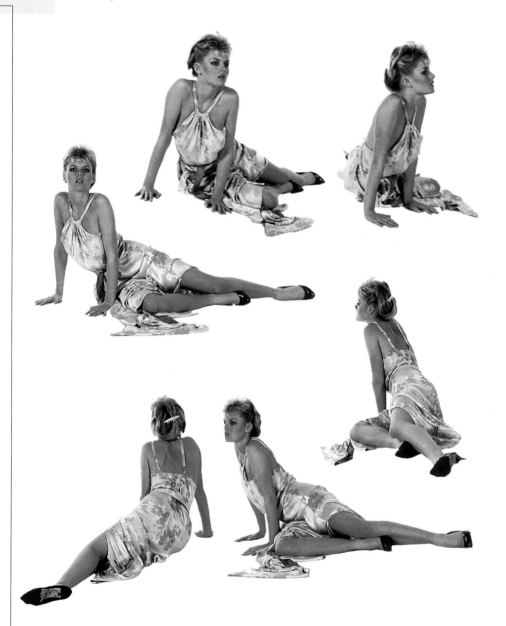

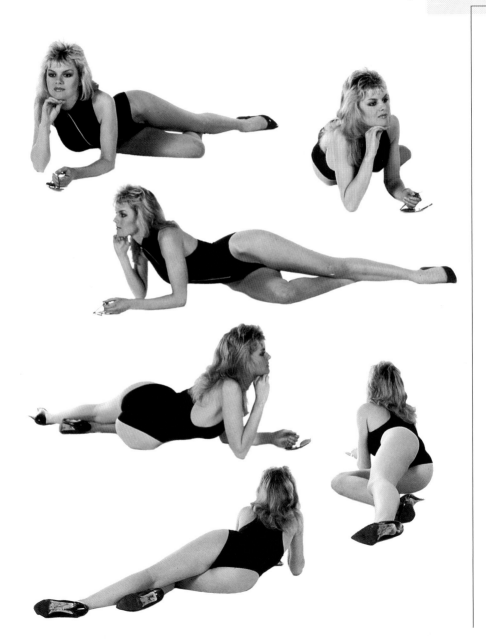

Pin-up

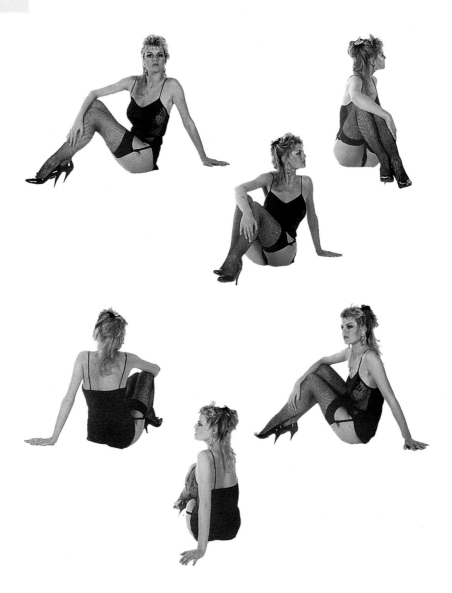

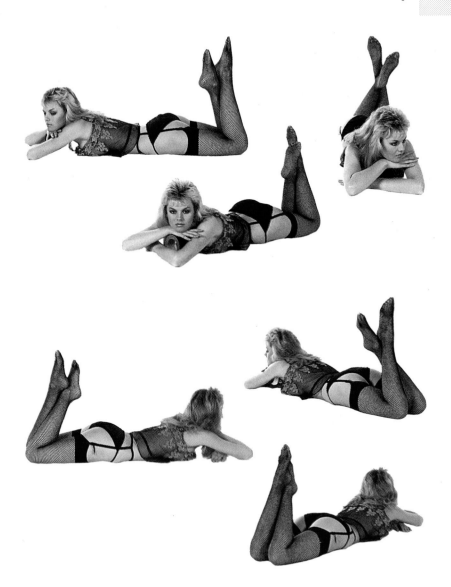

ACKNOWLEDGMENTS

Quarto Publishing would like to thank the following for their
assistance in the production of this book:

Alpine Sports Ltd
Bapty & Co. Ltd (weapons & militaria)
Estia Designs Ltd
Gordon Grose Sports
Lonsdale Sports Equipment Ltd
Mardi Gras (costumiers)
20th Century Props (costumiers)
Lee Robinson
Ben Smithies
Lousie Talbot-Weiss

CREDITS

Quarto Publishing would like to thank the following actors,
actresses and models for their work on this book:

Steve Beresford
Orla Brady
Matt Burton
Lucinda Galloway
Ruth Gordon
Simon Lambert
James Lumsden
Hannah Orthmann
John Sinnott
Carmen Stipetic